...ges of Modern America

WILLAMETTE
VALLEY
WINERIES

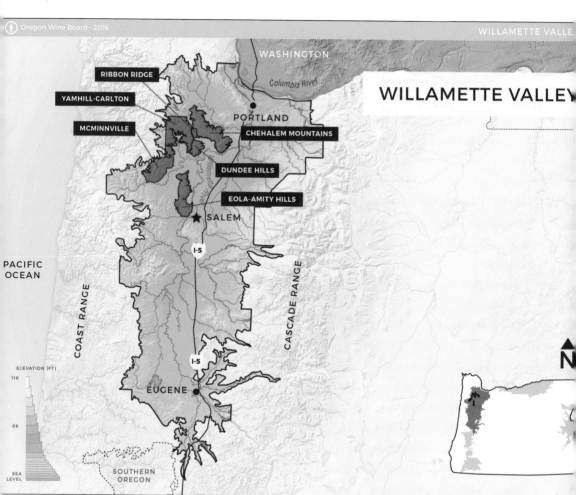

This 2016 map of the Willamette Valley American Viticulture Area (AVA), with sub-appellations noted, was produced by the Oregon Wine Board, a semi-independent state agency that manages marketing, research, and educational initiatives that promote the Oregon wine and wine grape industries. It is funded by winemakers and grape growers throughout the state. (Oregon Wine Board.)

Front cover: Dick Erath of Erath Vineyards measures a vine in the vineyard. Erath was one of the pioneers of winemaking in the Willamette Valley, moving his family to Oregon to pursue the vine in 1968. (Linfield College Oregon Wine History Archive.)

Upper Back Cover: An unidentified field worker brings in grapes at harvest. (Carolyn Wells-Kramer, CWK Photography.)

Lower Back Cover (from left to right): Wine enthusiasts walk through the vineyard at Alloro Vineyard with owner David Nemarnik, center, and winemaker Tom Fitzgerald in 2013 (Alloro Vineyard); Nancy Ponzi trails a vine in Ponzi Vineyards in 1978 (Ponzi Vineyards); Terry Casteel, founding winemaker of Bethel Heights Vineyard, surveys the harvest in 1990 (Linfield College Oregon Wine History Archive).

Images of Modern America

WILLAMETTE VALLEY WINERIES

BARBARA SMITH RANDALL

ARCADIA
PUBLISHING

Published by Arcadia Publishing
Charleston, South Carolina

Printed in the United States of America

Library of Congress Control Number: 2016960639

For all general information, please contact Arcadia Publishing:
Telephone 843-853-2070
Fax 843-853-0044
E-mail sales@arcadiapublishing.com
For customer service and orders:
Toll-Free 1-888-313-2665

Visit us on the Internet at www.arcadiapublishing.com

To Mark, Dave, Whit, and Cole, who make my world go 'round.

CONTENTS

ACKNOWLEDGMENTS

My friend Carl Giavanti warned me that once I started digging into the stories behind Oregon wines I would only be pulled deeper. He was right. I loved Oregon wines before I began this project, but my passion for them is now in full flame, fueled by the stories shared by winemakers and their families. They do not regard their lives as romantic or extraordinary; they simply answered a calling to grow the best grapes and make the best wines possible. A deep thank-you to all who welcomed me into your homes, vineyards, and wineries and shared your stories with me. I hope I have captured the essence of collaboration that permeates Willamette Valley wine history.

Thanks to Rachael Cristine Woody, Rich Schmidt, and Linfield student Shelby Cook at Linfield College's Oregon Wine History Archive for their assistance in preparing the photographs for this project. Unless otherwise noted, all photographs are from the archive, a treasury with delightful discoveries in every box. Thanks for being so welcoming and accommodating during my visits.

I owe immeasurable gratitude to my editor, Arcadia senior title manager Liz Gurley, for her guidance and encouragement in every step of this process. It was a pleasure working with you.

Thanks to Lauren Gaar of Dobbes Family Estate, who just happened to mention she knew Arcadia wanted this book to be written; to Carl Giavanti of Carl Giavanti Marketing; and to Dixie Huey of Trellis Growth Partners for introducing me to their winemaking clients. You know the nicest people.

Finally, thanks to Mark, Dave, Whit, and Cole for all the love and spice you add to my life; to Mom, Marie, Ted, and the rest of the Smith and Randall clans for your encouragement, especially Tom for your computer savvy; to the Barr family for your willingness to accompany me on winery "research" trips; and to the Birthday Girls and my BADD sisters, with whom I have shared more than a glass of wine over the decades. Your friendship and support mean more than I can express.

Cheers and thank you,
Barbara Smith Randall

INTRODUCTION

There is a story behind every glass of wine. It might be a tale about an early bud break or a season with unusually hot or wet weather or the winemaker's love of classical music or a beloved family member. No matter how the stories might be embellished, wines made in Oregon's Willamette Valley have a common origin, a heritage in fact. The wines tell a unique story of a group of people and their dreams, and how, against all odds, they succeeded in producing some of the best wines in the world through collaboration, ingenuity, and determination.

The Willamette Valley is a region of lush farm and forest land stretching from Eugene 150 miles north to the Columbia River and spreading 60 miles east and west between the Cascade Mountains and the Coast Range. The climate is temperate, with hot summers and colder winters; more than 42 inches of rain fall each year in the valley.

The land was considered too cold and wet to grow great grapes, though it is close to the same latitude as Burgundy, France, another wine region of special note. Wine has been made in the Willamette Valley since the 1880s.

German immigrant Ernest Reuter established Reuters Hill Winery in the north Willamette Valley in the early 1900s. He had quite a following for his klevner, a wine similar to pinot blanc, until the vineyard was destroyed when Prohibition was enacted in 1920, prohibiting the consumption, sale, and manufacturing of alcohol.

The Broetje family in Little America, now called Milwaukie, Oregon, grew Concord grapes for lambrusca wine prior to Prohibition. One son (name not known) carried on the tradition after Prohibition was repealed in 1933 until his death in 1943. His sister Dora Broetje took over until the early 1960s, when she retired in her early 80s.

Shortly after Prohibition was repealed, Salem businessmen John Wood and Sam Honeyman received bonded winery status and established Honeywood Wine Company, currently Oregon's oldest continuously operating winery. It was originally established as Columbia Distilleries, making fruit cordials, liqueurs, and brandies, but the company settled on making premium fruit and berry wines.

It would not be until the 1960s that winemaking began in earnest in the Willamette Valley, led by David Lett and Charles Coury.

Lett, who had studied at University of California, Davis (UC Davis) with Bill Fuller and Charles Coury, had fallen in love with pinot noir while touring France. When he tasted a Willamette Valley–grown strawberry, he was certain he had found the right region for growing grapes. He moved to Oregon and took a job selling textbooks so he could travel the state looking for just the right place to plant a vineyard. When he saw a promising site, he would stop and take a soil sample. He found his site in the Dundee Hills, and celebrated his honeymoon with Diana Lett by planting 3,000 pinot noir vines.

Coury also moved to Oregon in the mid-1960s and purchased the former Ernest Reuter vineyard, called Vine Hill. Coury would produce wine from 1970 to 1978.

In the 2012 Oregon Public Broadcasting documentary *Oregon Wine: Grapes of Place*, Myron Redford of Amity Vineyards said, "Lett and Coury had been told the rain would wash them out, they would grow fungus between their toes, it would rot their clothes off and there was no way in hell they would be able to grow great grapes up here."

Defying conventional wisdom, the men were convinced Burgundian varieties were better suited for Oregon than California. So they planted, and others followed. The early pioneers of the Willamette Valley wine region include David Adelsheim of Adelsheim Vineyards; Dick Erath of Erath Vineyards; Dick and Nancy Ponzi of Ponzi Vineyards; Myron Redford of Amity Vineyards; brothers Terry and Ted Casteel and their wives, Marilyn Webb and Pat Dudley, of Bethel Heights; and Bill Blosser and Susan Sokol Blosser of Sokol Blosser Winery.

The path was not without its bumps and pitfalls. The pioneers banded together to share labor, equipment, and knowledge to build the industry. They worked with state legislators to pass Senate Bill 100 in 1973, the Land Conservation and Development Act, which protected agricultural land from suburban sprawl, including hillsides that were perfect for vineyards. The winemakers also worked to secure the strictest labeling laws in the country in 1978, to protect the purity and source of wines produced in Oregon. They worked to establish the Oregon Wine Advisory Board (now the Oregon Wine Board), taxing winemakers and growers $25 per ton to fund the board, the highest tax of its kind in the world at that time.

With the 1980s came a big surge of new winemakers, people who needed and wanted help succeeding in the industry. The pioneers taught the newcomers what to plant and how to farm the vineyards properly. They worked to improve the quality of the grapes and the wine produced, knowing that one flaw in the market would reflect on the whole industry.

Finally, the pioneers saw their efforts paying off. At a blind tasting in New York City in 1985, Willamette Valley wines beat out French challengers for first, second, and third place and tied for fourth and fifth place. Thus, Robert Drouhin, of the noted Maison Joseph Drouhin family of Burgundy, France, purchased land in the Willamette Valley; his daughter Veronique Drouhin produced her first vintage in 1988.

Looking to the future, the winemakers set upon themselves sustainability and environmental guidelines. Sokol Blosser was the first to become Salmon Safe in 1996, complying with a third-party certification that promotes products made without pesticides or causing runoff that would be harmful to salmon. Several Oregon vintners founded the eco-certification LIVE (Low Impact Viticulture and Enology) sustainable practices in 1997, and Cooper Mountain Vineyards became Oregon's first Demeter Certified Biodynamic winery in 1999, a practice that entails a holistic view of treating the entire farm as a living organism. King Estate in Eugene became the first certified organic vineyard in 2002, incorporating all 465 acres of the vineyard.

The winemakers looked to support their vineyard workers by establishing a partnership with Tuality Healthcare to provide free health care for workers and their families in 1991. Called ¡Salud!, the program is funded by a gala pinot noir barrel auction each year.

To promote appreciation and knowledge of pinot noir around the world, the International Pinot Noir Conference was launched in 1987, bringing together winemakers, wine enthusiasts, journalists, and chefs for a weekend of wine tasting, learning, and good food. A main aspect of the conference is to promote the city of McMinnville as a destination for wine enthusiasts, as it sits in the heart of the Willamette Valley wine country.

What is the story behind these wines? It is a great tale filled with intrigue, courage, and love, lots of love—for the land, the vines, and especially the people. Pour yourself a glass of pinot noir, sit back, and turn the page.

Cheers!
Barbara Smith Randall

One

THE PIONEERS

Wine had been produced in the Willamette Valley since the 1880s, but it was not until David and Diana Lett planted 3,000 pinot noir vines in 1965 at The Eyrie Vineyard near Dundee that the industry began in earnest.

David Lett, Charles Coury, and Bill Fuller were three of the four students in the Department of Enology and Viticulture at the University of California, Davis in the early 1960s. Coury's undergraduate degree was in climatology, and he earned a master's degree in horticulture. His master's thesis, *Wine Grape Adaptation within the Napa Valley, California*, explained his cold limit amelioration hypothesis. Coury believed vinifera varieties produced the best quality wines when ripened just at the limit of the growing season. This was a revolutionary concept in 1963, one that Coury and Lett would set out to prove. They were convinced that excellent Burgundian and Alsatian wine grapes could be grown in the Willamette Valley.

Coury purchased the Reuter Vineyard, abandoned since Prohibition, to start his vineyard and nursery. He traveled through Europe after graduating from UC Davis; fell in love with pinot noir; and supposedly brought back grapevine root stock from French vineyards in his suitcase, sending clippings through the agriculture quarantine center in San Francisco. These "suitcase clones" would become the famed Coury Clones, a Pommard clone with a flavor profile complementary to Wadensvil. The Coury Clone would become the most widely planted vine in the Willamette Valley.

Others followed the lead of Lett and Coury and founded wineries of their own, including David Adelsheim of Adelsheim Vineyards; Dick Erath of Erath Winery; Dick and Nancy Ponzi of Ponzi Winery; Terry and Ted Casteel, along with their wives and a sister-in-law, of Bethel Heights Vineyards; Bill and Susan Sokol Blosser of Sokol Blosser Winery; Myron Redford of Amity Vineyards; Ron and Marjorie Vulsteke of Oak Knoll Winery; and Bill Fuller of Tualatin Valley Vineyards. None of the pioneers had any winemaking experience except for Fuller, who had been at Louis Martini in California before coming to Oregon. Collaboration was the key to their success. The pioneers shared equipment, manpower, and expertise.

To protect vineyard property from suburban sprawl, winemakers worked with legislators to pass Senate Bill 100, the Land Conservation and Development Act, which set aside land for future agricultural use, including hillsides, which are prime vineyard land.

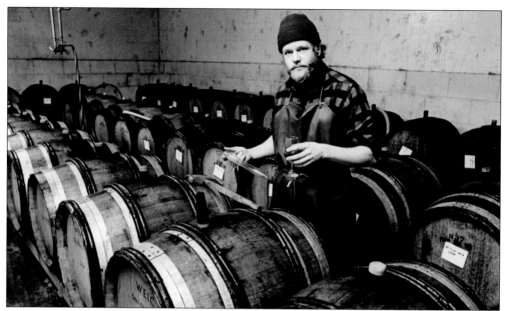

David Lett was known as "Papa Pinot," a nickname that gives a nod to his groundbreaking work establishing pinot noir in the Willamette Valley. From his studies at UC Davis, he was convinced that cool-weather varietals such as pinot noir would thrive in the region. He planted 3,000 pinot noir vines over his honeymoon at his vineyard, The Eyrie, blessing them with a pouring of Burgundian wine. Lett's 1975 South Block Reserve Pinot Noir placed in the top 10 in a blind tasting at the Gault-Millau Wine Olympiad in 1979; it was up against the finest Burgundy wines. That was just a hint of what was to come from the Willamette Valley region.

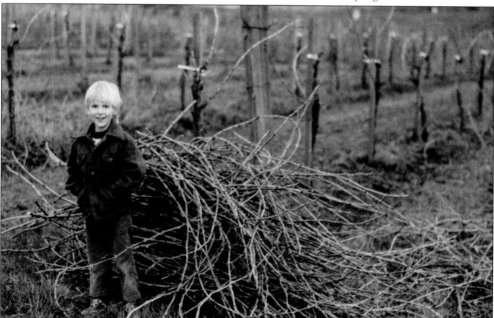

As with all family businesses, children were expected to help with chores in the vineyard and winery. Jason Lett, David and Diana Lett's younger son, is pictured by a pile of vine clippings, which he presumably cut.

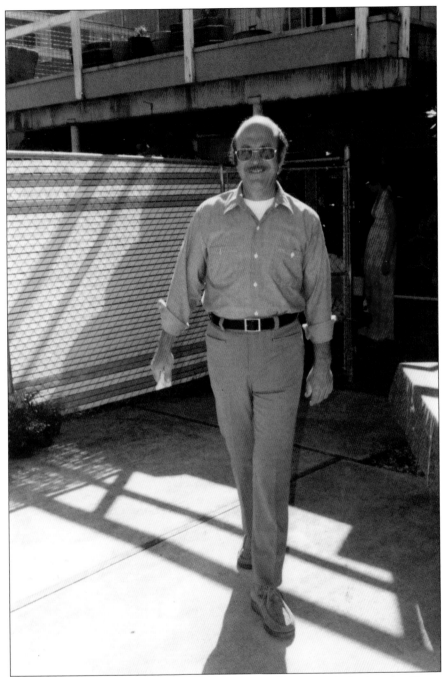

Charles "Chuck" Coury set out to prove the hypothesis of his master's thesis—that Burgundian wines could thrive in Oregon's climate, a revolutionary concept in the early 1960s. After graduating from UC Davis, he visited vineyards in France, learning more about the grapes and the wines they produced. He brought root stock back in his suitcase and sent clippings of vines to the San Francisco agricultural quarantine center. These became known as the Coury Clones, a Pommard clone with a unique flavor profile. The clone would become the most widely planted grape in the region. (Coury family collection.)

Charles Coury and his wife, Shirley, bought the Reuter vineyard near Forest Grove in 1965. Because of his background in climatology and his studies at UC Davis, Coury was looked upon by other winemakers for education. He was instrumental in securing wine labeling regulations, quarantines on plant materials, and establishing a viticultural research program at Oregon State University. He taught viticulture courses at the community college in Roseburg, in the neighboring American Viticulture Area (AVA) to the south. He planted 25 acres of his vineyard in pinot noir, chardonnay, Gewurtztraminer, and Riesling. Note the stainless steel fermentation tank at left. Below, Coury's father, Charles "Pops" Coury, adjusts the wine press his son made. (Both, Coury family collection.)

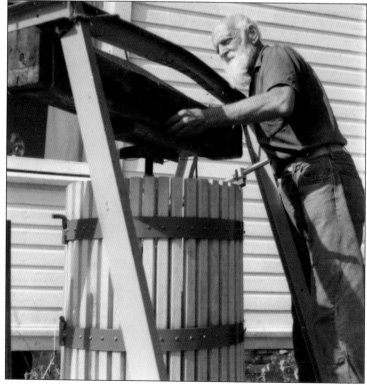

At right, Charles Coury and son Charley Coury, with his dog Gypsy, pose with family friends on the new tractor purchased before the vineyard was planted. Charley Coury was about eight years old in the photograph. He regards this as one of his favorite photographs of his father. Charley also particularly likes the 1971 photograph below of his father, as it shows his typical smile. Pictured with Coury is family friend Manu Taylor. Dave Wirtz was the first winemaker at Charles Coury Vineyards. (Both, Coury family collection.)

These are pictures of the farmhouse on the property Coury purchased in 1965. David Teppola, who grew grapes at Laurel Ridge Vineyard on his Finn Hill Farm, invested with Coury in the mid-1970s. They produced several vintages together before Coury left the winery in 1978. Teppola sold the wine inventory to pay off creditors; the bank asked him to stay on to manage the vineyard. Teppola and his wife, Susan, continued operating both vineyards until the mid-1980s, when Mike and Kay Dowsett purchased the Coury property. Longtime friends of Teppola, Helmut and Lilo Wetzel, wished to move from Alaska, and the Teppolas proposed the formation of a new company involving all three couples and both properties, to be run from the Coury facilities. The new company could absorb all the grapes produced at the Teppolas' Laurel Ridge Vineyard and the Coury property. This arrangement continued until 2000, when the Dowsetts sold to the current owner, Mylan Stoynov, who wished to have his own winery. He named the property David Hill Estate. The Wetzels then founded Chateau Bianca, and the Teppolas built their own winery in the Carlton area. (Both, Coury family collection.)

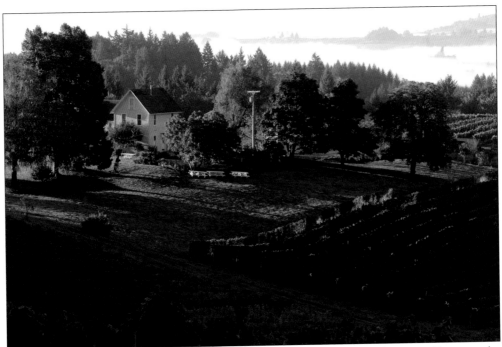

This is a picture of the current David Hill Estate, originally Reuter's farmhouse and home to the Coury family from 1965 to 1978. After leaving the wine industry in 1978, Coury became Oregon's first craft brewer, founding Cartwright Brewing Company. Oregon Public Broadcasting would produce *Beervana*, a documentary that tells his story. Coury left the beer industry in 1982, moving with his wife to Calistoga, California, where he owned a bicycle shop for tourists. Toward the end of his life, he returned to the wine business with involvement in ozone cleaning technologies for the winery industry. He died in 2004. (David Hill Estate.)

Amity Vineyards was planted in 1971 by Jerry and Anne Preston. Myron Redford; his wife, Vikki Wetle; and business partner Janis Checchia partnered with the Prestons in 1974 and bought them out in 1976. Myron Redford learned to make wine after he overheard a conversation between Lloyd Woodburne and Neal Peak about their winery, Associated Vintners Winery, in Bellevue, Washington. Redford asked to visit, which led to a part-time job. For the next three years, he learned winemaking from these two Washington winemaking pioneers. Pictured with Redford is business partner Janis Checchia.

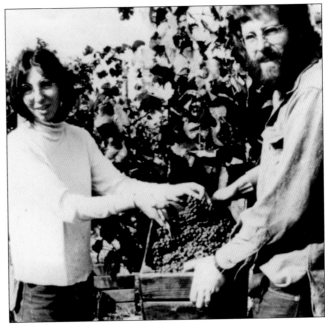

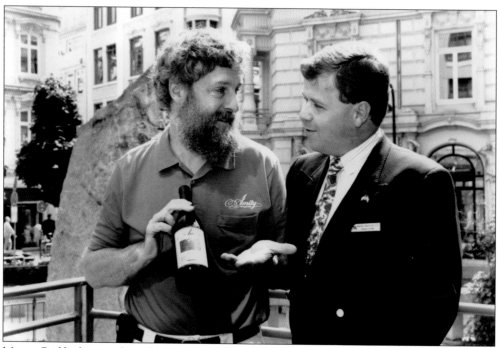

Myron Redford remembers drinking wines made by Italian families in California and aged in redwood tanks, which he bought by the case at $1 per bottle in 1969. He was stunned at how much better the wines were when allowed to age for a year in the bottle. He stated in an interview at Linfield College that "bottle aging develops layers and complexity." He said he always wanted to make wines that were a mix of David Lett at The Eyrie and Dick Erath at Erath Vineyards. "I would use David Lett's structure and put it with the voluptuousness of Erath's wines. If David's wines were Twiggy and Erath's were Dolly Parton, I'd mix them to make a nice Meryl Streep somewhere in the middle." Above, he poses with a German dignitary on a trip to Hamburg in 1999. Below is a note handwritten on Hamburg Marriott letterhead.

David Adelsheim was one of the pioneering winemakers and was instrumental in helping bring about positive legislation to protect designated farmland. He created maps of the area that showed land that was valuable for growing grapes, and argued successfully that not only low-level land was valuable for agriculture, but also hillsides, where grapes thrive.

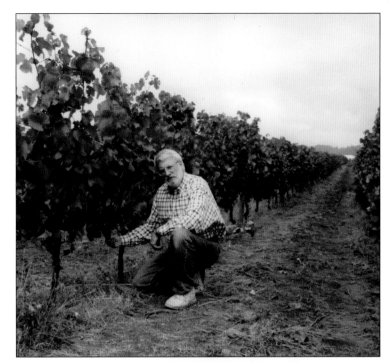

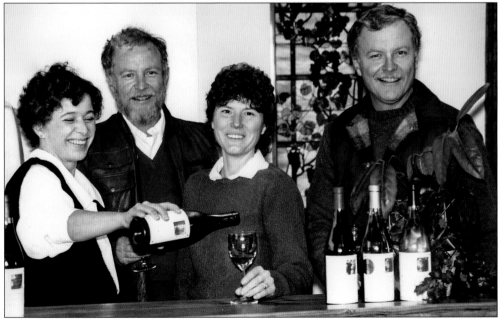

From left to right are Bethel Heights Vineyard founders Pat Dudley; Ted Casteel; Ted's wife, Marilyn Webb; and Terry Casteel enjoying a glass of their wine. The twin brothers and their wives, plus Dudley's sister Barbara Dudley, founded the winery in 1977. They raised their children on the property, playing among the vineyard rows. The children are now participating in the operation of the winery. Mimi Casteel, daughter of Ted and Pat, serves as "queen of experimental vineyard design," focusing on innovations in composting, vermiculture, and sustainable farming. Ben, son of Terry and Marilyn, has been a winemaker since 2006.

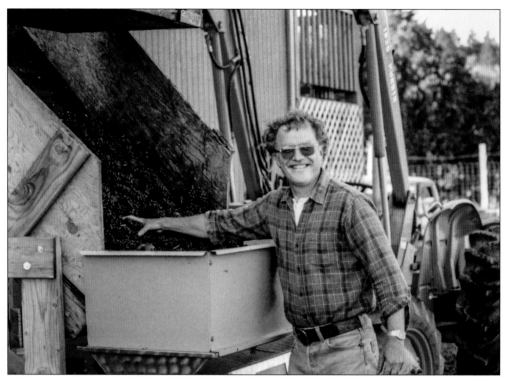

Terry Casteel, the original winemaker at Bethel Heights Vineyard, surveys the grapes at harvest. The Casteel brothers and their wives left a life in academia to start the winery. They were colleagues of Myron Redford at the University of Washington before moving to the Willamette Valley. The vineyard is still family owned and operated. Terry is winemaker emeritus, Pat is the marketing director, Marilyn is the chief financial officer, and Ted still manages the vineyard. Below is a sign leading into Bethel Heights Vineyard, which the second generation is now running.

Dick and Nancy Ponzi moved their family to the Willamette Valley in the late 1960s, in a spirit of adventure and the pursuit of making world-class pinot noir. Several researching trips to Burgundy convinced them the Willamette Valley was where they should settle, and in 1970, Ponzi Vineyards was founded. The Ponzi family was instrumental in the growth of the Willamette Valley wine industry. While Dick served as winemaker, Nancy was involved with increasing awareness of pinot noir by being a founding force of the International Pinot Noir Conference and bettering the lives of vineyard workers by helping found ¡Salud!, a free health care program for workers and their families. The Ponzi children all took an active role in the wine business. Daughter Luisa, pictured with her father, is now the winemaker. Son Michel serves as director of operations, and Maria is president.

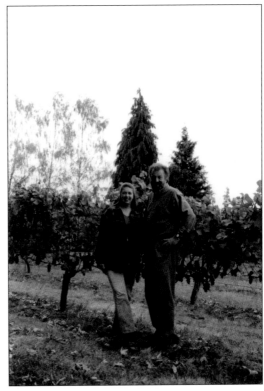

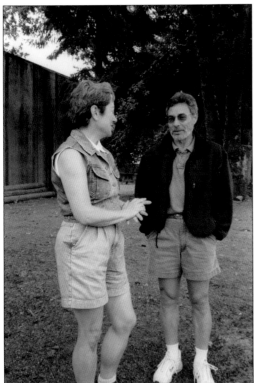

Bill Blosser and his wife, Susan Sokol Blosser, came to Oregon in 1970 and cleared an abandoned prune orchard for their vineyard. The two knew little about farming or winemaking but had a passion to make the best wine possible. Bill had been an urban planner before turning to winemaking, a background that proved valuable for navigating the bureaucracy to secure legislation helpful to the growth of the industry. Susan enjoyed the work of winemaking more than Bill. She mastered every aspect of vineyard work, production, and marketing. The Sokol-Blossers divorced, but both remained involved with the business, now run by their children. Pictured are Susan Sokol Blosser and Russ Rosner, who came on as the second winemaker for Sokol Blosser in 1998. He and Susan married in 2007.

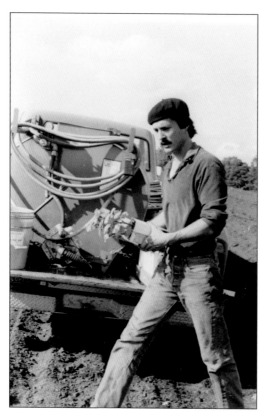

Bill Blosser plants pinot noir in the Old Vineyard Block in 1971. Susan Sokol Blosser and Bill Blosser were heavily involved in building the infrastructure of the wine industry. Bill Blosser's experience as land use planner was utilized in securing favorable agricultural land use laws, which protected farmland from urban sprawl.

Bill Fuller founded Tualatin Valley Vineyards in 1973. At the time, he was the only Willamette Valley winemaker who had any previous experience making commercial wines prior to coming to Oregon. He had studied with David Lett and Charles Coury at UC Davis and then made wine in California with Louis Martini.

Bill Fuller planted his vineyard in the north Willamette Valley near present-day Hillsboro, close to Charles Coury's vineyard. This newsletter shows who had recently planted new vineyards, including Doyle Hinman, who founded Hinman Vineyards outside of Eugene.

Due to very busy schedules which include planning for the third annual Wine Festival, the June monthly meeting will be canceled. By the way, can YOU help on the festival? Assistance needed in the following areas:

I. "Greatest of the Grape"---wine stewards

II. "Wine Fair" Fairgrounds---Ticket sales, Build O.W.G.A. Booth, Work in O.W.G.A. Booth, Work in other Booths, Art show

III. "Centennial Gourmet Dinner"---Wine Stewards

IV. Wine Cookery

The next O.W.G.A. meeting will be a lamb barbecue at Bjelland Vineyards on July 30 at 4 P.M. Call Bjelland Vineyards for reservations. Dr. V. Anderson will be the chef again. Reservations are limited so hurry. Cost will be $3.00 per adult plus a dish to pass.

Additional information to be published in O.W.G.A.'s Vineyards Directory

OWNER	NAME and LOCATION	ACRES PLANTED	In '72	FUTURE
Jerry Preston	Amity Vineyards N. of Amity, E on Rice Lane, N on Reservoir Rd. ½ mile	10	3	35
Dr. Verner Anderson & Howard Hunsaker	Monte Verde Vineyard Elgarose Loop Rd. Melrose Area of Roseburg	8	0	0
Paul Bjelland	Bjelland Vineyards Reston Road Roseburg	29	0	46
Doyle Hinman	Hinman Vineyards Briggs Hill Rd. Eugene	0	5	10
Ted Anderson & Charles May	Karica Vineyard Melrose area Roseburg	8	0	0
Harley Widener	---------------- SE of Hwy 99 South South of Roseburg	4½	0	0

Bill Fuller kept calendars and journals with entries of all aspects of winery life. He noted when he planted, who helped, yield reports, temperatures, expenses, trips, and much more.

MONDAY, FEBRUARY 12, 1973
43rd Day

Lincoln's Birthday

A LEGAL HOLIDAY

TUESDAY, FEBRUARY 13, 1973
44th Day

Signed Papers with Bill M. to establish M.F. Vineyards!

WEDNESDAY, FEBRUARY 14, 1973
45th Day

Told Louis I am moving to Oregon and will quit at end of March.

THURSDAY, FEBRUARY 15, 1973
46th Day

TUESDAY, JULY 24, 1973
205th Day

9
10 Mike & Doyle helped Courys
11 Crew 9 hours each
12 Bruce & James 3½ hours pulling
1 weeds & 4½ hours installed emitter
2 Fuller & Malkmus Asst.
3 Coury's crew
4
Evening

WEDNESDAY, JULY 25, 1973
206th Day

9 Mike ill
10 Gail Took his place
11 Bruce & James installed emitter 8½h
12 Gail & Doyle helped Coury's crew 8½h
1 Fuller & Malkmus Asst Coury's
2 crew
3
4
Evening

Bill Fuller's calendars are a great resource for those wanting to learn more about enology and viticulture activities.

Dick Erath, left, and C. Calvert "Cal" Knudsen, right, partnered in 1972 to start Knudsen Erath Winery. Knudsen bought 200 acres in the Dundee Hills in 1971 and started planting pinot noir and chardonnay on 125 acres. Erath built a home and winery next to the vineyard. Most vineyards measured two to five acres; Knudsen's was the Willamette Valley's first large-scale pinot noir vineyard.

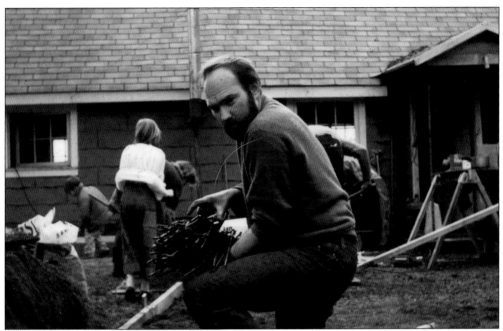

Dick Erath made his first barrel of wine in his garage in California before moving his family to Oregon in 1968. During his years in the Willamette Valley, Erath designed and constructed the Erath Winery, received the Best American Pinot Noir award, and slowly expanded both nationally and, in 1994, internationally. In 2003, the Erath Winery transitioned from Erath as the principal winemaker to Gary Horner. In 2006, Ste. Michelle Wine Estates bought the Erath Winery. Since this transition, Erath Winery has continued to rank among the most successful wineries in the industry and has continued to represent the strength of Oregon wines in the international wine world.

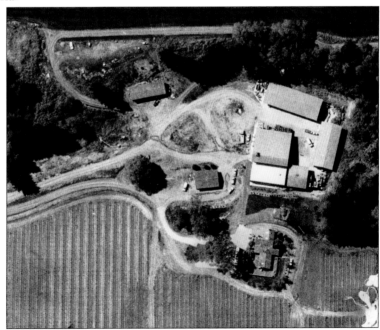

This aerial shot of the Knudsen Erath Winery was taken in 1974. The road at the top leads to the Knudsen cabin, where the family stays when visiting the vineyard. (Knudsen Vineyards.)

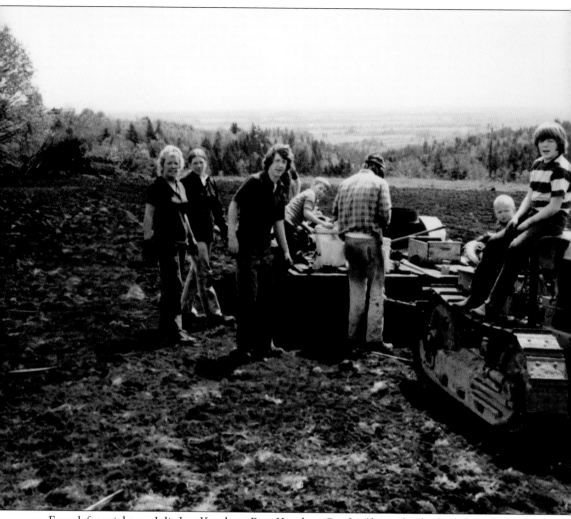

From left to right are Julie Lee Knudsen, Page Knudsen Cowles (formerly Elizabeth Page Knudsen), Colin Knudsen, one of Dick Erath's children, an unidentified worker, another Erath child, and David Knudsen taking a break from helping clear land for a vineyard on either the Erath or Knudsen property. (Knudsen Vineyards.)

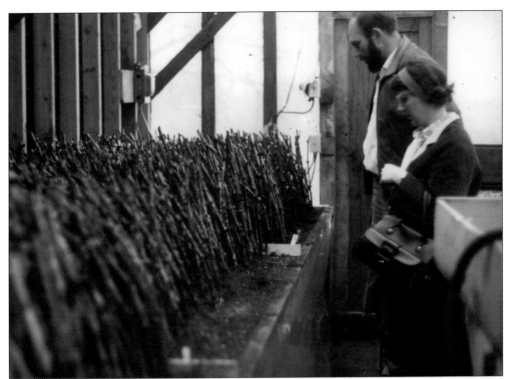

Above, Dick Erath examines vines with Lois March. Erath planted 23 varieties of grapes on just four acres in 1969, discovering that pinot noir was the most successful. He continued his trailblazing winemaking by producing 216 cases of commercial wine, the first in the area, in 1972. At right, grapes await processing as harvest is under way at Erath Vineyards.

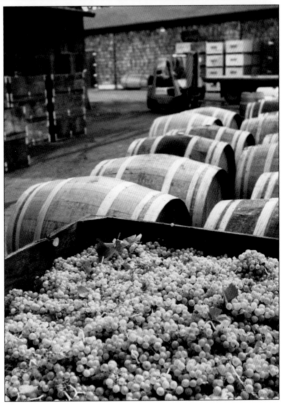

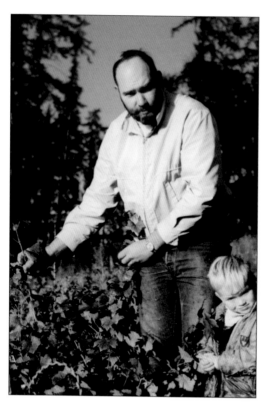

Dick Erath and his son Cal pose in the vineyard nursery behind the logger's cabin on Kings Grade Road in Newberg. The family lived in the unheated cabin, which sat on 49 acres, for several years before breaking ground on the first winery in Dundee in 1976. Below, Dick poses with a yardstick and a vine in the vineyard. He sold his winery in 2006 to St. Michelle Wine Estates with the commitment that they would keep the Erath brand.

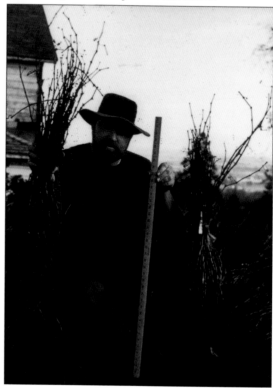

Cal Knudsen's interest in wines began when he and his wife, Julia Lee Knudsen, toured Europe in 1954. Before that, he had never had a glass of wine, but he fell in love with it and became a dedicated wine buff. According an article in the *Seattle Times* published upon his death in 2009, when Knudsen signed an earnest money contract for an orchard he wanted to buy, the seller tore up the contract and fired the broker when he found out Knudsen planned to plant a vineyard. Apparently, the man belonged to a religious group that forbade the use or production of alcoholic beverages. It took Knudsen about a year to find another site, but he purchased it at an even better price. (Knudsen Vineyards.)

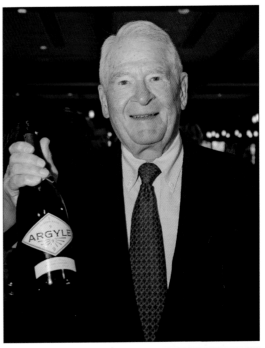

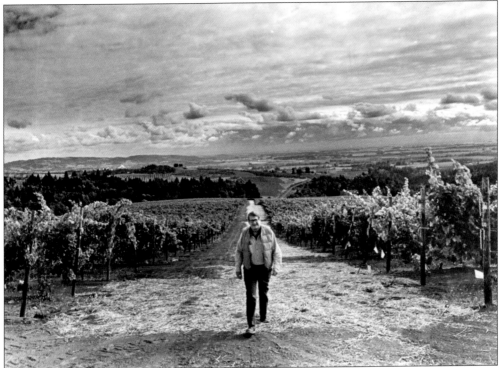

Knudsen Erath split up in 1987, and Cal Knudsen led a group of investors to buy into Argyle Winery, bringing cash, business acumen, and a perfectly situated vineyard to the partnership. Knudsen served as chairman at Argyle from 1990 until his retirement in 2007. This 2008 photograph shows Cal Knudsen in his vineyard in the Dundee Hills. He died in 2009. (Knudsen Vineyards.)

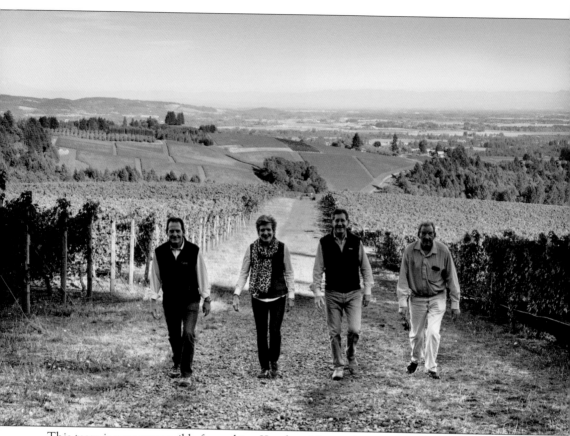

This team is now responsible for making Knudsen Vineyard wines. From left to right are David Callison Knudsen, Page Knudsen Cowles, Colin Roderick Knudsen, and Cal Knudsen Jr. (Knudsen Vineyards.)

The Campbells are another Willamette Valley family with deep roots in winemaking. Pat Campbell's great-grandfather emigrated from Switzerland and settled in the Helvetia area just north of present-day Elk Cove Vineyard. He grew grapes and made wine prior to Prohibition. Pat's parents had fruit orchards in the Parkdale area near the base of Mount Hood. Pat and Joe, who was from the Mount Hood area, met as teenagers picking strawberries during the summer for spending money. Joe graduated from Harvard University and then attended Stanford Medical School. (Both, Elk Cove Vineyards.)

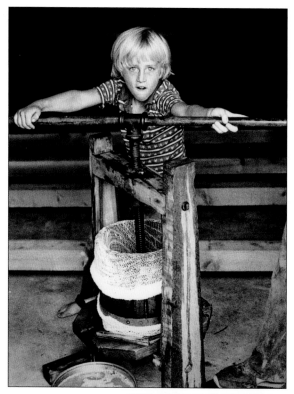

The Campbells brought their children to the abandoned and overgrown homestead that would become Elk Cove Vineyard in 1974. They lived in a trailer for a year before converting the homesteader's barn into a winery and building a new house from the reclaimed wood. All the children helped with vineyard and winery chores. In 1979, the Campbells got proof they could produce world-class wine when their 1978 Riesling won gold at the Oregon State Fair, the Tri-Cities Wine Festival, and the Seattle Enological Society's annual tasting. Of all their children, it was Adam who took an interest in winemaking. Here, he gives an apple press a turn and attempts to give his father a lift in a wheelbarrow. (Both, Elk Cove Vineyards.)

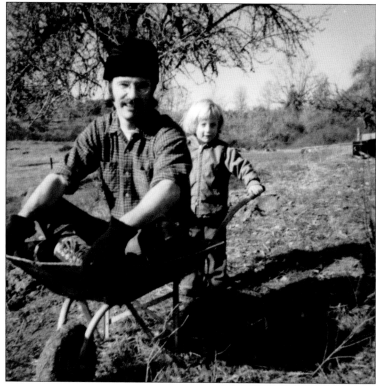

Adam Campbell earned a degree in political science at Lewis and Clark College and worked summers in the winery before determining he wanted to join his parents in winemaking in 1996. He and other second-generation winemakers spend time collaborating, just as their parents did prior to joining the industry. Anna Campbell, Adam's sister, also works for Elk Cove Vineyards as the creative director. Adam is now the head winemaker for Elk Cove Vineyards. (Elk Cove Vineyards.)

Ken Durant was an engineer with CH2M Hill in Corvallis. His wife, Penny, grew up on a cattle ranch in California, and according to their son Paul Durant, her Irish heritage made her crave connections to the land. The couple made it their mission to purchase property, and they began their vineyard in 1973. They grew grapes that they sold to neighboring winemakers, including Bill Blosser of Sokol Blosser Winery, a coworker of Durant's at CH2M Hill. (Durant family collection.)

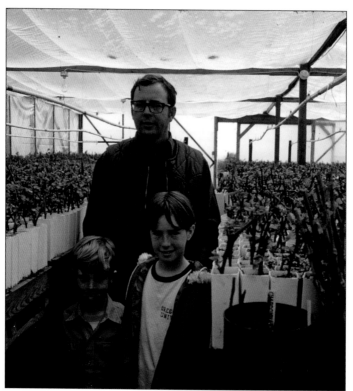

Paul Durant and his sister Katie loved growing up on the vineyard, and like children of other pioneering families, they helped with vineyard planting and maintenance. The whole family enjoyed farming, and Penny would eventually expand the estate to include a native plant nursery and greenhouses. The Durants added guest quarters on the property, calling the estate Red Ridge Farm. They later added an olive orchard with five different varieties and an olive milling center, producing cold-pressed olive oils. They began making wine from their vineyard in the mid-1990s. (Both, Durant family collection.)

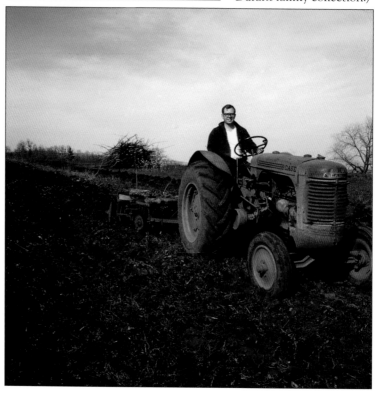

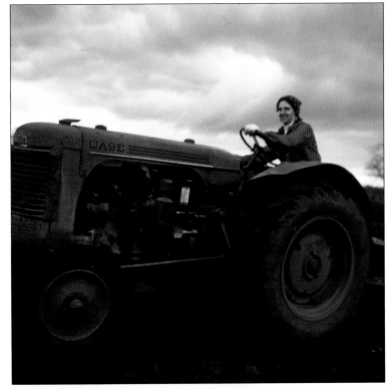

Penny Durant loved working the land and managing the vineyard. For many years, the Durants sold their grapes to neighbors to make wine, but later Ken Durant made wine commercially. Paul Durant is now the winemaker of the family. Below, Katie Durant poses with clusters of grapes ready to harvest. (Both, Durant Vineyards.)

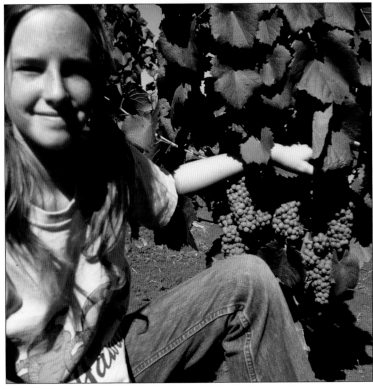

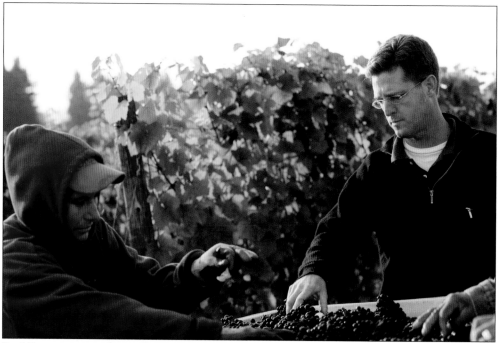

Paul Durant is a mechanical engineer by profession but always loved farming. When his parents were in their mid-70s, he decided to return to the vineyard to work with them, later taking over operation of the vineyard and winemaking, the olive orchard, the gardens, and the rest of the property. "I didn't just start a new chapter," he said. "I started a new book." Paul Durant now runs the farm and vineyard and serves as winemaker. (Durant Vineyards.)

Ron and Marjorie Vulsteke founded Oak Knoll Winery in 1970 on the site of a dairy farm of the same name, making it the first winery in Washington County. Marjorie was skilled in culinary arts; making home wines was second nature to her. Winemaking was in Ron's family; his grandfather had been a winemaker in the St. Emilion region of Bordeaux in the early 1900s before immigrating to the United States. The grandparents came to the north Willamette Valley to be near family who settled before them. Oak Knoll Winery pinot noir first received acclaim when the 1980 Vintage Select won Best of Show and the Governor's Award at the 1983 Oregon State Fair. The Vulsteke children are now involved in the winemaking industry, and their cousins have founded 51 Weeks, operating out of an urban winery in Portland.

Doyle Hinman of Eugene and his partners David and Annette Smith founded Hinman Vineyards in 1979. Unlike many winemakers who have a job to support their winery, Hinman started out with the idea of making a living by making wine. "I wanted it to be my way of life," he said in an interview with the *Register Guard* in 1989. "That meant a lot of hard work and the need for quick results." The article stated that from his first crush, which produced 630 cases of wine, Hinman's production increased to more than 30,000 cases per year. Hinman credited the growth to "partly good business, partly good people and the rest economic necessity." By 1989, Hinman Vineyards was the largest wine seller in Oregon. (Doyle Hinman collection.)

Hinman and David and Annette Smith focused on making wines that were "market driven," a path not taken by many winemakers. Their goal was first to make "impeccable wines," then evaluate what people wanted from wines and make those wines. That meant selling wines through supermarkets and large chain stores throughout Oregon and under two labels—Hinman Vineyards, marketed as everyday wine, and a premium brand, Silvan Ridge Wines. Hinman went after the restaurant trade as well. The winery was also the first in Oregon to package varietal wines—premium wines made from a single variety of grape—in 18-liter boxes, enabling restaurants to serve premium Oregon wines at competitive prices. Pictured are unidentified friends of Hinman's. (Both, Doyle Hinman collection.)

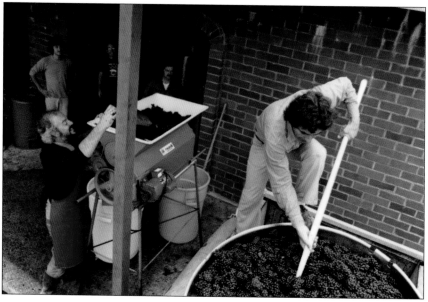

Dick (pictured) and Nancy Ponzi brought their family to Oregon in the late 1960s, after several research trips to Burgundy, France. They found an ideal location and purchased 20 acres southwest of Portland. Though the Pacific Northwest was not favored as a location to grow pinot noir, they felt the north Willamette Valley climate was perfect for growing cool-climate varieties of grapes. They planted their estate vineyard in 1970 and made their first barrels of wine in 1974. Dick and Nancy Ponzi have been honored many times for their contributions to Oregon's wine industry. Dick was honored by *Wine Advocate* in 1988 as one of the world's best winemakers and Oregon's Best Producer. Nancy cofounded the International Pinot Noir Conference, the Pinot Camp, programs that promote pinot noir, and ¡Salud!, a program providing free health care to vineyard workers and their families. (Carolyn Wells-Kramer, CWK Photography.)

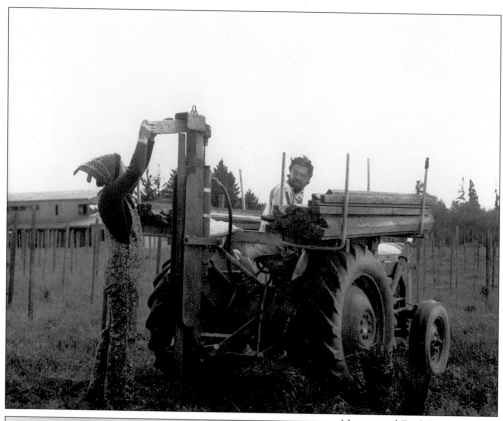

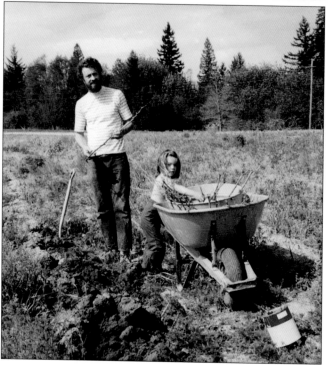

Nancy and Dick Ponzi, above, plant pinot noir vines in the estate vineyard in 1970, and at left, Dick and daughter Luisa plant vines. It was her job to water and pat the dirt on top of the vine cuttings, earning her the nickname "Slug." The parents passed along their passion for winemaking to their children, including their thoughtful methods and philosophy. Luisa would complete postgraduate enological studies in Beaune, France, in 1993. She received the certificate Brevet Professionnel D'Oenologie et Viticulture, the first American woman to earn such a prestigious distinction. She took the reins as winemaker at Ponzi that same year. (Both, Ponzi Vineyards.)

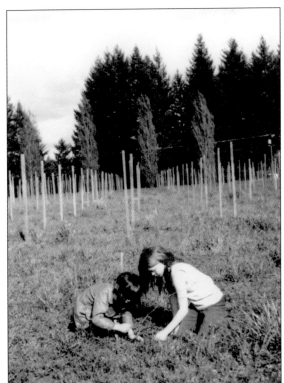

Dick and Nancy Ponzi's daughters Luisa and Maria plant vines together in the vineyard, while Nancy trails a vine in the vineyard. The family planted pinot gris in 1978, a variety not well known in the region at that time. The winery was featured in the *New York Times* in 1978 for its pinot noir, a first for Oregon wines. They have continued to add vineyards in the Chehalem Mountain area. (Both, Ponzi Vineyards.)

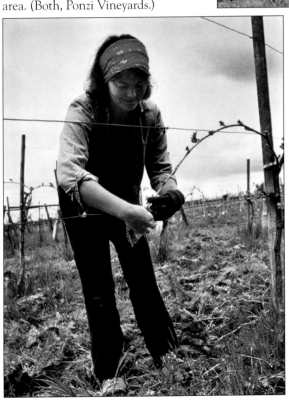

Ponzi Vineyards is now under the direction of the second generation. Dick and Nancy Ponzi's son Michel Ponzi was named director of operations in 1985, Maria Ponzi was named marketing director in 1991 and president in 1994, and Luisa was named winemaker in 1993. The three children assumed full-time responsibility and ownership of the winery in 1994. The awards keep coming for the wine and for the family. Ponzi pinot noir ranked in *Wine Spectator*'s Top 100 for the first time in 1987, and wine critic Robert Parker named Ponzi pinot noir as "Oregon's most complex pinot noir," associating it with the great wines of Burgundy in 1988. Dick and Nancy Ponzi received lifetime achievement awards in 2004 and 2007 for their contributions, and Dick received the American Center for Wine, Food and the Arts Vintner of the Year award in 2005. (Andrea Johnson and Ponzi Vineyards.)

Two

SETTING THE INFRASTRUCTURE

Stunning success took place at the Gault-Millau Wine Olympiad in Paris, France, in 1979. The Eyrie Vineyard's 1975 South Block Reserve Pinot Noir placed in the top 10 in a blind tasting among the finest Burgundies. A rematch proposed by Robert Drouhin, of the noted French winemaking family Maison Joseph Drouhin, in 1980 confirmed the results. Willamette Valley winemakers recognized they needed structure to ensure quality and cohesiveness in the industry, as the excellence one winery may achieve could be ruined by another producing a lesser product. Seeking support for the fledgling industry, the winemakers turned to legislators.

Oregon passed two groundbreaking pieces of legislation in 1973: Senate Bills 100 and 101. These bills established the Oregon Department of Land Conservation and Development and required the creation of statewide planning goals and the protection of designated farmland. Pioneer vintners David Adelsheim and David Lett, among others in the wine-growing community, lobbied county planning commissions to restrict residential growth in the areas the men believed would be profitable as vineyards, producing maps to illustrate the areas. The maps served as visual aids for Adelsheim and Lett during their meetings with the commissions and are a reminder of how much work these men and others put in to ensure the success of the industry.

Winemakers also petitioned Gov. Victor Atiyeh to start a wine advisory board, funded by a tax they imposed on themselves.

The winemakers also worked to enact strict labeling laws stipulating that to include the designation "Willamette Valley" on a label, 100 percent of the grapes must be grown in the Willamette Valley. In early years, when Willamette Valley vineyards were not yet producing, many winemakers used grapes from the area around Walla Walla, Washington, to make their wine, passing it off as Willamette Valley. This law restricted that practice, protecting the Willamette Valley brand.

Getting people to the vineyards and wineries was the next concern. The first Thanksgiving Weekend in the Wine Country was held in 1983, organized by a group of Yamhill County winemakers. This began a tradition of celebrating the release of new vintages over the holiday weekend, a popular practice that continues today.

Working with the state department of tourism, the winemakers installed blue and white highway signs directing wine enthusiasts to the wineries. Today, kiosks with detailed maps have been erected at key highway points to direct visitors to individual wineries.

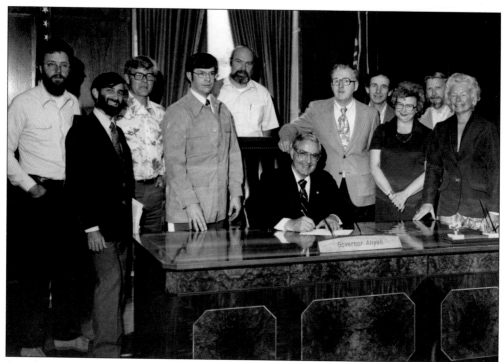

Spearheaded by winemakers in the Willamette Valley in 1977, the Wine Research Advisory Board (WAB) created a tax purely on grapes for a period of four years. After the WAB turned into the Oregon Wine Board, a decision was made in 1981 to increase the tax on grapes. Here, Gov. Victor G. Atiyeh signs the legislation to increase the tax. Pictured are, from left to right, Myron Redford, Bill Nelson, Scott Henry, state senator Tony Meeken, Dick Erath, Governor Atiyeh, Ben Mafit, Richard Sommer, Marjorie Vuylsteke, Ronald Vuylsteke, and unidentified.

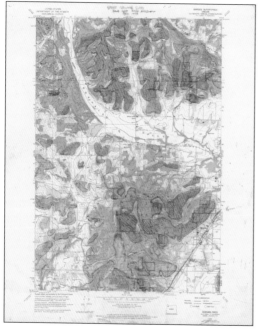

With the creation of the Land Conservation and Development laws in 1973, each region was responsible for establishing a plan for land use, primarily to keep suburban sprawl from encroaching on agricultural land. David Adelsheim and David Lett, representing Willamette Valley winemakers, created maps showing land suitable for vineyards, including hillsides, which were not usable for farmland but were ideal for growing grapes. Their campaign was successful, and land was set aside for future vineyards.

Bill Fuller, left, and Myron Redford, right, were champions for educating fellow winemakers in best practices and methods for winemaking. Monthly winemaker meetings were held at fire halls and local restaurants to allow winemakers to gather and share information. Redford said Chuck Coury was an effective educator for winemakers, sharing what he had learned at UC Davis with others.

Pres. Lyndon Johnson's Highway Beautification Act of 1965 banned billboards and roadside signs, making it difficult to direct people to wineries and other attractions. However, a new program allowing "tourist-oriented directional signs (TODS)," which informed but did not advertise, was enacted during the Carter administration. Heading Carter's Department of Transportation was former Oregon governor Neil Goldsmith, and winery owners hoped that Oregon would be a shoe-in to be included in the pilot program. That did not happen, and the program was not approved until Ronald Reagan's administration. The first TODS sign was ceremonially installed at Sokol Blosser by Governor Atiyeh. To make travel between wineries and tasting rooms easier, the Oregon Department of Transportation erected directional signs to wineries throughout the state. Susan Sokol Blosser, with the help of other winemakers, was instrumental in making the directional signs a reality. Today, travel kiosks are placed throughout the Willamette Valley to direct guests to wineries, most of which are tucked away on country roads throughout the region.

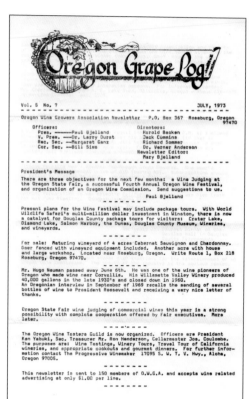

The Oregon Wine Growers Association was the early industry organization, with a focus more strongly on the social aspects of the wine industry. Willamette Valley winemakers shifted the focus to technology and methodology, as they wanted to learn how to make the best wines possible. Noted in this issue is the death of winemaker Hugo Neuman, who had a winery near Corvallis from the late 1930s through 1960.

Page two of the newsletter indicated other resources available to winemakers at the time, including a magazine out of Colorado and a California newsletter. Neither would have information pertinent to Oregon's climate and conditions, though.

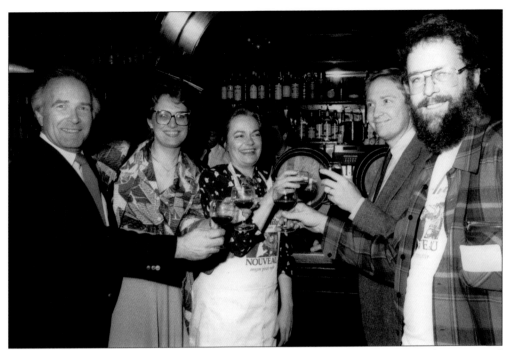

Myron Redford (far right), winemaker at Amity Vineyards, greets guests at the inaugural Thanksgiving Weekend in the Wine Country event. It was the first invitation for consumers to come and sample wines from the winery.

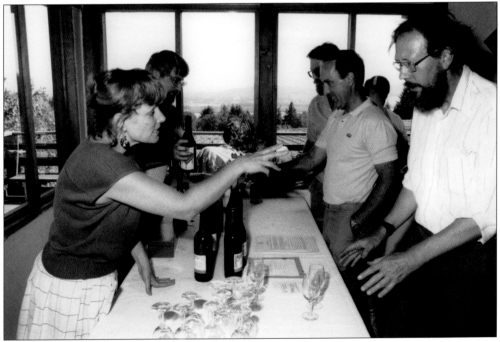

David Adelsheim (far right), winemaker at Adelsheim Vineyards, serves wine from his winery at the first Thanksgiving Weekend in the Wine Country. Adelsheim was instrumental in securing farmland for future vineyards and other advances in the Willamette Valley wine industry.

Many wineries did not have tasting rooms in the early days of the industry, so winemaking facilities were set up for tastings. Consumers enjoyed getting a firsthand view of the surroundings, often their first time in a winery. This winery is not identified.

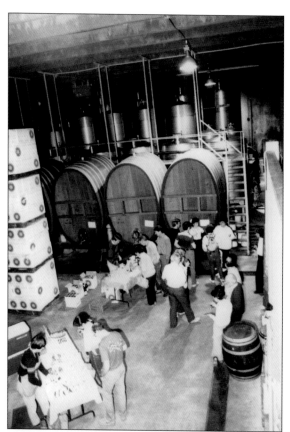

Marjorie Vulsteke (at center in floral blouse), winemaker and founder of Oak Knoll Winery in Hillsboro, poses with pourers preparing for the inaugural Thanksgiving Weekend in the Wine Country. The event likely took place in the winery, which was installed in a former milking parlor. She and her husband, Ron Vulsteke, were heavily involved in building the infrastructure of Willamette Valley's wine industry. Ron worked at Tektronix, an electronics firm in the area. Dick Erath, another Willamette Valley pioneer winemaker of note, also worked at Tektronix when he first moved to Oregon.

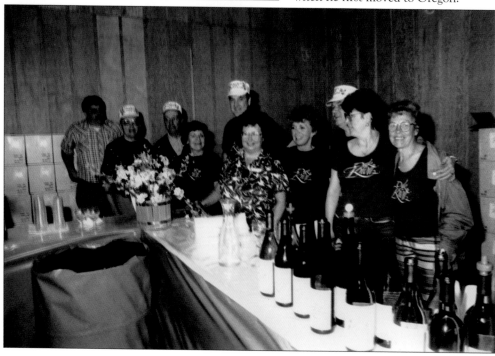

Sommelier Phillip DeVito was instrumental in introducing fine wines to the public. As sommelier at Oregon's only four-star resort, Salishan Lodge, from 1970 to 1992, he graciously introduced diners to fine wines from Oregon and beyond. He built the lodge's excellent wine cellar, created pairings for diners, and organized cellar tours and tastings for lodge guests. Committed to developing an appreciation of fine wine within the general public, he educated locals, guests, and Salishan staff members about wines. This photograph was taken when he addressed members of the Oregon Wine Association at its annual meeting in 1987.

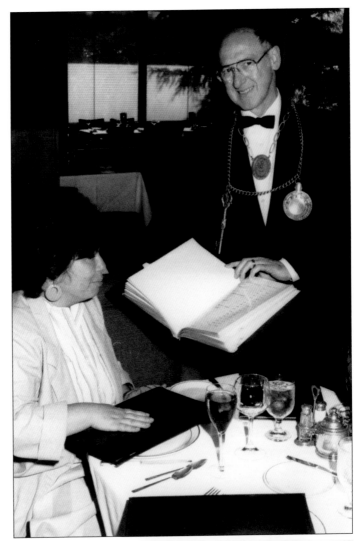

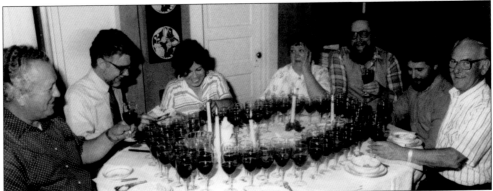

Things could be extreme at some tastings, as winemakers poured several glasses of their finest to impress customers. Private tasting like this could be held in a person's home, to keep driving under the influence of intoxicants to a minimum.

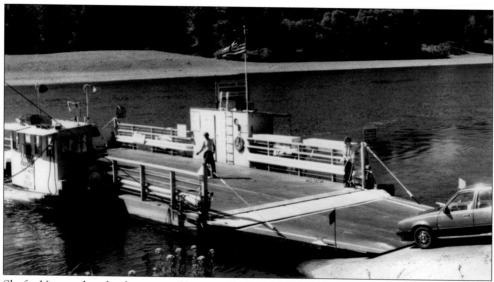

Shafer Vineyard took advantage of its proximity to the Wheatland Ferry to invite consumers to ride the ferry across the Willamette River to attend its Sunday afternoon jazz concerts. Visitors to the Shafer Vineyard were encouraged to bring a picnic and enjoy a bottle of wine while soaking up the summer sun and ambiance of the music and vineyard. The Wheatland Ferry is still in operation today and affords winery visitors to the Eola-Amity Hills AVA a delightful ride over the river and through the woods. The ferry is a quick drive from the I-5 freeway at Woodburn.

Tastings became more sophisticated as the years progressed and included gourmet cheeses and cured meat pairings, provided by either the winemaker or a vendor. Tastings also began occurring throughout the Willamette Valley on Memorial Day weekend, recreating the excitement of the Thanksgiving event. As more wineries added tasting rooms to their properties, tastings could occur each weekend and throughout the week in some cases.

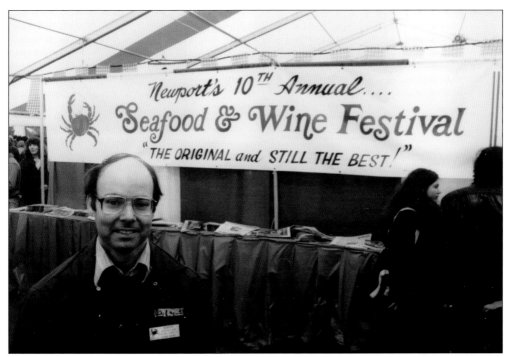

The Newport (Oregon) Seafood & Wine Festival was founded in 1976 to bring tourists to the coast during the off season. The festival was intended to treat consumers to tasty seafood, showing them how versatile and easy it is to cook. As a bonus, organizers included wines, mainly Oregon wines, in the festival, giving consumers an opportunity to taste the varieties and meet the winemakers. Today, the event is the longest-running wine festival in the Northwest and includes both commercial and amateur wine competitions. The festival is held the last weekend in February.

Sponsored by the Newport Chamber of Commerce, the Newport Seafood & Wine Festival is held the last weekend of February, with limited admission for tastings Thursday through Sunday. The weather is most often blustery at the coast that time of year, and organizers tell stories of tents being upended by the wind and ending up in the bay. Admission is limited to ensure participants can sample from each vendor, which includes seafood restaurants and wineries from around the Northwest. The event gives attendees a sneak peek at spring releases of wines.

Oak Knoll invited the public to attend an annual outdoor festival of food, wine, and live music, but people had to bring their own chairs or blankets. Admission was minimal, and children were allowed. Local bands, such as the one seen below, were invited to play at Oak Knoll's festival. This became a popular practice to draw customers to the wineries. Outdoor events were common at wineries and still are. Some, like Brooks Winery in Eola-Hills AVA, have a children's area and even offer kid-friendly snacks while parents are wine tasting.

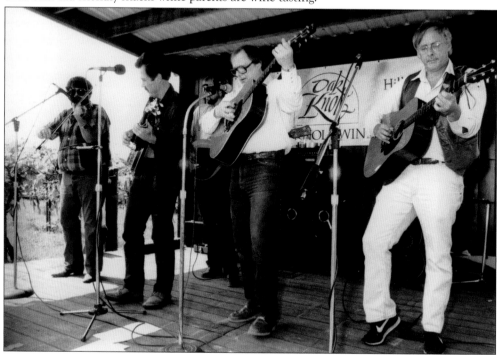

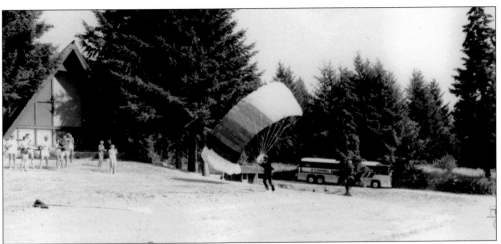

Doyle Hinman, who with partner David Smith founded Hinman Vineyards near Eugene in 1979, used a variety of promotions to draw crowds to his vineyard. One stunt had a parachute glider fly into the winery; other events brought guests out from Eugene via a radio station's bus. Hinman did not remember the parachute glider but recognized his A-frame house, in which his family lived for 20 years. Hinman built a winery on the premises and later sold the property to the Chambers family. Daughter Elizabeth Chambers runs the property now, as an extension of Elizabeth Chambers Cellars; her original winery and tasting room are located in McMinnville. Hinman continues to make wine for private label companies. (Hinman Vineyards.)

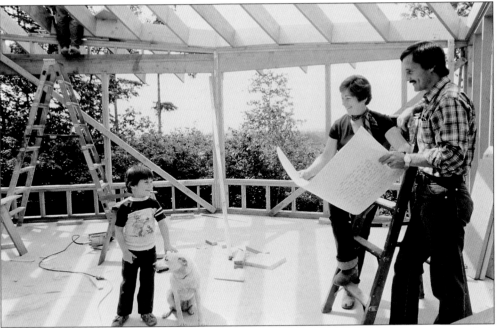

Bill and Susan Sokol Blosser were among the first to build a dedicated tasting room at their vineyard. Here, they review the plans with their son Alex. Alex joined the family business in 1998, and Russ Rosner was named winemaker. Their daughter Alison Sokol Blosser joined the business in 2004, and in 2006, the 30th vintage was celebrated. In 2008, after a year of slowly taking over the daily operations from Susan, Alex and Alison become the company's co-presidents on January 2. Alex became head winemaker in 2013. (Sokol Blosser Winery.)

Jackson Browne

Elektra Entertainment

PHOTO CREDIT : NELS ISRAELSON

For several years, Susan Sokol Blosser contracted with an entertainment company to present a series of summer concerts featuring top national acts, such as Jackson Brown and Harry Belafonte, before deciding she could produce the shows herself at less expense. Producing the concerts presented more of a headache than anticipated. Unusual rain that summer caused vehicles to become stuck in the lawn and vineyards. At the end of the season, Susan Sokol Blosser vowed to stay with what she knew best: growing grapes for making wine.

After serving on the Dayton School Board, Susan Sokol Blosser was asked to run for the Oregon House of Representatives in 1986. The incumbent mailed campaign materials the Saturday before the election indicating that since Sokol Blosser owned a winery, she would be soft on drunk driving, where the incumbent had a record of being tough. The mailer raised enough doubt to get the incumbent reelected. Two years later, she ran for the Oregon Senate, and vineyard neighbor Penny Durant ran her campaign. Her opponent—the brother of the incumbent who had defeated her for the House seat—stood for everything she was against. He led Oregon's Right to Life movement, homeschooled his children and had no experience with the public school system, and promoted antihomosexual legislation. Sokol Blosser was told, "This election was yours to lose." A last-minute mailer sent by the opponent accused Sokol Blosser of endorsing homosexuality. She lost that election as well, presumably due to her supporting homosexuality and abortion, the fact that she was a woman, and her business producing alcoholic beverages. Disappointed by the losses, she returned to tending the vineyard for solace.

Oregon Wine Press began publishing in 1984, with a mission to bring news of Oregon wines, pinot noir, food, vineyards, winemakers, and insider industry happenings to consumers on a monthly basis. The publication was purchased and re-imagined in 2006 by the News-Register Publishing Company in McMinnville.

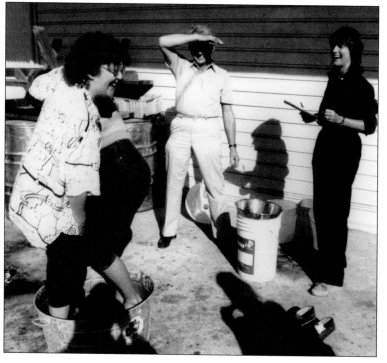

Including consumers in the winemaking process was fun for both winemakers and wine enthusiasts. Here, guests at St. Josef's Winery in Canby take a turn at stomping grapes the old-fashioned way—by foot. Winemaker Josef Fleischmann, at center shading his eyes from the sun, looks on as unidentified grape stompers have a go at it. Today, many wineries invite guests to attend harvest events such as this.

Finally, success comes to the winemakers of the Willamette Valley. On September 12, 1985, the International Wine Center in New York City conducted a blind tasting of ten 1983 Oregon pinot noirs against seven wines of the same vintage from Burgundy, France. Oregon wines took first, second, and third place and tied for fourth and fifth with French wines. First and second place wines were made by Bob McRichie, winemaker for Yamhill Valley Vineyards and Sokol Blosser; third place went to David Adelsheim of Adelsheim Vineyard, and fourth went to David Lett of The Eyrie Vineyard, tying with a wine made by Phillip Rossignol. This triggered tremendous interest around the world in Willamette Valley wines.

For immediate release:

September 23, 1985

OREGON '83 PINOT NOIRS DOMINATE

COMPARATIVE TASTING WITH '83 FRENCH BURGUNDIES

(New York, NY)--A prestigious group of wine writers and wine importers decisively selected Oregon '83 Pinot noirs over like vintages from among the leading wine producers of Burgundy, France in a comparative blind tasting hosted by the staff of the International Wine Center in New York City.

"Dominance of Oregon wines in this tasting confirms that Oregon winemakers have, in a few years, achieved world-class status with their product, matching centuries of European tradition," said Fred Delkin, director of marketing for the Oregon Wine Advisory Board.

The tasting was held September 12, after the International Wine Center selected 10 Oregon '83 Pinot noirs and seven Burgundy entries in separate pre-screening tastings. The comparative judging was conducted by noted wine writer Terry Robards.

By a significant margin, Oregon '83 Pinot noirs, at an average retail cost of $11, garnered the first three places. The best showing for the '83 Burgundies were a fourth and fifth place tie with other Oregon entries. The average retail price for the French Burgundies is $24.

Yamhill Valley Winery, of McMinnville, led the rankings, followed closely by Sokol-Blosser Winery's Red Hills Vineyard '83 Pinot noir. Both wines were made by Dr. Bob McRitchie, winemaker of Sokol-Blosser of Dundee who produced the Yamhill Valley vintage for winery owner Dennis Burger.

Placing third was Adelsheim Vineyard, of Newberg, followed by The Eyrie Vineyards, of McMinnville, in fourth with both a Volnay Cuvee Blondeau, Hospices de Beaune; and a Beaune Clos des Mouches, Joseph Drouhin.

Knudsen-Erath Winery of Dundee tied for fifth place, with a Gevrey Chambertin, Phillip Rossignol.

WINE
ADVISORY BOARD
1324 S.W. 21ST AVENUE
PORTLAND, OR 97201
(503) 224-8167

page 2

"The results of the tasting have confirmed what we have maintained for years, that Oregon Pinot noirs and French Burgundies are more alike in style than any other two wines," said Bill Blosser of Sokol Blosser Winery and a member of the Oregon Wine Advisory Board who represented the industry at the event.

He added that winemakers themselves already consider the '83 Oregon Pinot noirs to be among the finest vintages produced in Oregon's winemaking history.

"Most surprising to those involved in the tasting was that no one could differentiate between the Oregon Pinot noirs and the French Burgundies," said Linda Lawry, one of the organizers of the event at the International Wine Center. "This tasting further reinforced the positive image of Oregon wines."

Other wineries that were represented in the tasting were Elk Cove Vinyards, Gaston; Hidden Springs Winery, Amity; Alpine Vineyard, Monroe; Siskiyou Vineyards, Cave Junction; and Amity Vineyards of Amity.

Other vintage '83 Burgundies tasted were from, Clos des Lambrays, Domain des Lambrays; Volnay Santemotos, Domain Joseph Matrot; Nuits St. Georges, Domain Henri Gouges; and Chambolle Musigny, Domain Comte Georges de Vogue.

-30-

Contact, Monica Sopke
224-8167

Bill Blosser of Sokol Blosser Vineyard and a member of the Oregon Wine Board representing the Oregon wines at the event said the results confirmed that Oregon pinot noir and French burgundies are more alike in style than any other wines. Other Willamette Valley wineries participating included Knudsen Erath, which took fifth place, besting Gevrey Chambertin, Phillip Rossignol, Elk Cove Vineyards, Hidden Springs Winery, Alpine Valley, and Amity Vineyards.

OREGON•WINES

OREGON
WINE ADVISORY
BOARD

M E M O R A N D U M

TO: ALL OREGON WINERIES

FROM: MYRON REDFORD
 RANDY CLARK

DATE: OCTOBER 1, 1987

RE: THE OREGON CHALLENGE: PART II
 1985 CHARDONNAY TASTE-OFF

A big congratulations and thank you to all the wineries who
participated in yesterdays comparative tasting of Oregon
Chardonnays and French white burgundies at the
International Wine Center in New York.

Although Oregon didn't rank one, two and three in the
tasters' preference -- there is some outstanding news. In
the top 8 preferred wines, there were 4 Oregon wines and 4
French wines.

Plus, we think the results show a comparison much more
interesting:

Average price of the French wine:	$	40.71
Average price of the Oregon wine:	$	12.14

The taste preferences are like a shuffled deck of cards --
Oregon wines fit right in with the French wines all the way
down the line. However, the Oregon wine shows a greater
value to the consumer by far.

Detailed results are enclosed. We'll send you a press
release as soon as it's available.

/rnc
enc.

Marketing &
Public Information:
701 N.E. Hood Avenue
Gresham, Oregon 97030
(503) 665-1560

Business Office:
Department of Agriculture
635 Capitol Street N.E.
Salem, Oregon 97310
(503) 378-3787

After the success of the blind
tasting of the 1983 pinot noirs,
the Willamette Valley winemakers
proposed a second challenge,
this time a blind tasting of 1985
chardonnays against French
white burgundies. This challenge
took place again at New York's
International Wine Center. While
the Oregon chardonnays did
not sweep the competition, they
made impressive showings. The
Oregon wines were considered
excellent values also, with prices
a fraction of the French wines.

The chardonnay challenge took
place September 30, 1987, with
extremely encouraging results.
The top eight best wines included
four French and four Willamette
Valley wines. "The taste preferences
are like a shuffled deck of cards,"
Amity Vineyard's Myron Redford
reported. "Oregon wines fit
right in with the French wines
all the way down the line."

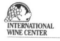

INTERNATIONAL
WINE CENTER

144 West 55 Street
New York, NY 10019
212 757 0518

THE OREGON CHALLENGE
September 30, 1987

1. 1985 Tualatin Chardonnay, Willamette Valley, Private Reserve, Estate Bottled
2. 1985 Adams Chardonnay, Yamhill County, Reserve
3. 1985 Veritas Vineyard Chardonnay
4. 1985 Meursault Charmes, Pierre Morey
5. 1985 Chateau Benoit Chardonnay
6. 1985 Shafer Vineyard Cellars Chardonnay, Willamette Valley
7. 1985 Chablis Grand Cru, "Les Preuses", Jean Dauvissat
8. 1985 Meursault-Genevrieres, Domaine Bernard Michelot
9. 1985 Bethel Heights Vineyard Chardonnay, Willamette Valley
10. 1985 The Eyrie Vineyards Chardonnay, Willamette Valley, Yamhill County
11. 1985 Batard-Montrachet, Pierre Morey
12. 1985 Ponzi Chardonnay, Willamette Valley
13. 1985 Chassagne-Montrachet, 1er Cru "Les Vergers"
14. 1985 Oak Knoll Chardonnay, Willamette Valley
15. 1985 Puligny-Montrachet, "Les Pucelles", Domaine Leflaive
16. 1985 Valley View Vineyard Chardonnay, Estate Bottled
17. 1985 Corton-Charlemagne, Tollot-Beaut & Fils
18. 1985 Cameron Chardonnay, Willamette Valley

This page shows the results of the tasting by preference ranking. The Eyrie's Willamette Valley Chardonnay, which sold at the time for $12.50 a bottle, beat out Corton Charlemagne and Meursault-Genevrieres, which sold for $57 and $34.50 per bottle, respectively. Bethel Heights, Chateau Benoit, and Oak Knoll chardonnays had impressive showings also, besting Meursault-Charmes Pierre Morey. Shafer Vineyard Cellars and Ponzi Vineyards were ranked higher than Chassagne-Montrachet Premier Cru.

THE OREGON CHALLENGE: PART II
1985 Oregon Chardonnay and French White Burgundy
September 30, 1987
International Wine Center o New York

Preference Placing	Wine	Retail Price
1.	Batard-Montrachet, Pierre Morey	$ 69.00
2.	Puligny-Montrachet, "Les Pucelles", Domaine Le Flaive	$ 40.00
3.	The Eyrie Vineyard, Willamette Valley Yamhill County	$ 12.50
3.	Corton Charlemagne, Tollot-Beaut et fils	$ 57.00
4.	Meursault-Genevrieres, Domaine Bernard Michelot	$ 34.50
5.	Bethel Heights Vineyard, Willamette Valley	$ 12.00
5.	Chateau Benoit Winery	$ 10.00
5.	Oak Knoll Winery, Willamette Valley	$ 12.00
6.	Meursault Charmes, Pierre Morey	$ 33.50
7.	Shafer Vineyard Cellars, Willamette Valley	$ 11.00
7.	Ponzi Vineyards	$ 12.00
7.	Chassagne-Montrachet, Premiere Cru, "Les Vergers"	$ 34.00
7.	Cameron Wines, Willamette Valley	$ 10.00
8.	Tualatin Valley Vineyards, Estate Bottled, Private Reserve Willamette Valley	$ 13.00
8.	Adams Vineyard Winery, Yamhill County Reserve	$ 12.00
8.	Chablis Grand Cru "Les Preuses", Jean Dauvissat	$ 17.00
8.	Valley View Vineyard Winery, Estate Bottled	$ 17.00
9.	Veritas Vineyard	$ 12.00

85 WINE

Tasting order of Wine	Retail Cost	Votes of preference	French ID vote	Oregon ID vote	Correct selection percentage
Tualatin Valley Vineyards	$ 13.00	1	5	19	79%
Adams Yamhill Co. Reserve	$ 12.00	1	13	10	43%
Veritas	$ 12.00	0	9	16	64%
Meursault Charmes Pierre Morey	$ 33.50	3	17	6	74%
Chateau Benoit	$ 10.00	4	5	19	79%
Shafer Wine Cellar Willamette Valley	$ 11.00	2	7	17	71%
Chablis Grand Cru "Les Preuses" Joan Dauvissat	$ 17.00	1	6	16	27%
Meursault-Genevrieres Domaine Bernard Michelot	34.50	5	14	10	58%
Bethel Heights Willamette Valley	$ 12.00	4	10	15	60%
Eyrie Vineyard Yamhill County	$ 12.50	6	8	14	64%
Batard-Montrachet Pierre Morey	$ 69.00	13	16	8	67%
Ponzi Vineyard Willamette Valley	$ 12.00	2	7	17	71%
Chassagne-Montrachet Premiere Cru "Les Vergers"	34.00	2	12	10	54%
Oak Knoll Winery Willamette Valley	$ 12.00	4	6	17	74%
Puligny-Montrachet "Les Pucelles" Domaine Le Flaive	$ 40.00	9	13	11	54%
Valley View Vineyard Estate Bottled	17.00	1	6	18	75%
Corton Charlemagne Tollot-Beaut et fils	57.00	6	11	13	46%
Cameron Wines Willamette Valley	$ 10.00	2	5	19	79%

This table gives more details of the tasting results. Mersault-Charmes Pierre Morey was by far the most preferred wine in the tasting. The Willamette Valley's Adams Yamhill Company and Bethel Heights were strongly identified as being French wines, and Corton Charlemagne was thought to be an Oregon wine. The Willamette Valley winemakers were especially encouraged by the tasting results, and they have continued to improve the quality. Oregon chardonnays are award-winning wines today.

The Eyrie Vineyards

Dick Ponzi, David Lett, & David Adelsheim telling the Oregon story, early 1990s

Knowing that if they wanted to be successful they needed to raise awareness and build markets for their wines outside the state, Dick Ponzi, David Lett, and David Adelsheim began touring, sharing samples in New York City and other key cities around the United States.

Three

TEACHING
THE NEWCOMERS

In the late 1970s and into the 1980s, new winemakers began coming to the Willamette Valley, fueled by the lower land prices compared to California property and the desire to make excellent wine. This big surge of new winemakers needed help learning what and how to plant, and the pioneers were eager to share their knowledge.

The blind tasting wins of 1979, 1980, and 1985 inspired Robert Drouhin to purchase 30 acres in the Dundee Hills. His daughter Veronique came to intern with David Lett and other winemakers to learn the differences between the French and Oregon methods and considerations. She made her first vintage in 1988.

Change was coming to the region. The Willamette Valley became Oregon's first American Viticulture Area in 1983, and the industry acts to sustain resources for the future through carbon neutral, ecological, environmental programs, such as Salmon Safe, which promotes products made without pesticides or causing runoff that would harm salmon; LIVE (Low Impact Viticulture and Enology) certification of sustainable practices; and Demeter Certified Biodynamic certification, a holistic practice of treating the entire farm as a living organism. Vineyards have become organic, and solar energy is used to power entire winery operations.

"There was a much higher calling than trying to imitate some other place and that goal was to figure out who we wanted to be for ourselves and what it was that we could do that nobody else in the world could do," said David Adelsheim in the documentary *Oregon Wine: Grapes in Place*.

Training programs were launched at Chemeketa Community College and Oregon State University to train vineyard management skills and winemaking skills. Linfield College launched the Oregon Wine History Archive and later began a wine studies program.

By the late 1990s and early 2000s, urban wineries and shared multi-winery facilities opened, giving winemakers an opportunity to share costs, equipment, and labor. The spirit of collaboration that drove the success of the original winemaking pioneers pervades.

While the Willamette Valley celebrated its 50th year as a wine region in 2016, several Willamette Valley winemakers celebrated their 30th years making wine, one of whom was Joe Dobbes, founder and winemaker of Wine by Joe, Jovino, and Dobbes Family Estate. Dobbes carefully selects fruit from vineyards with different elevations, soil types, and grape clones for cuvees, or blends. His single-vineyard wines are an expression of each vineyard's unique terroir, how the climate, soils, and terrain affect the taste of the wine. (Dobbes Family Estate.)

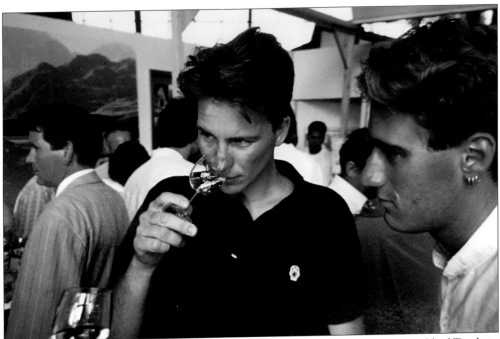

Joe Dobbes began his winemaking career in 1985, apprenticing at Weingut Erbhof Tesch in Germany's Nahe region and at Dominique G. Roumier and Domaine des Comtes Lafon in Burgundy, France. He then honed his skills working in Alsace with Domaine Ostertag. When he returned to the United States, he produced wine for Elk Cove Vineyards, Eola Hills, Hinman/ Silvan Ridge, Paschal Winery, and Willamette Valley Vineyards before launching Wine by Joe, a custom winemaking company, in 2002. (Both, Dobbes Family Estate.)

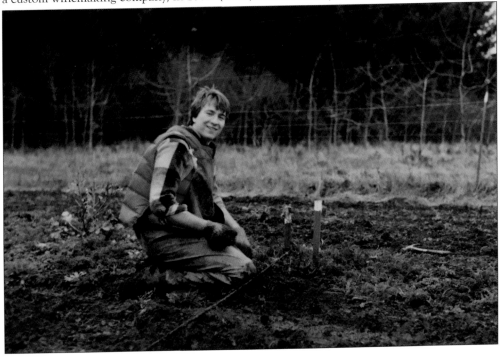

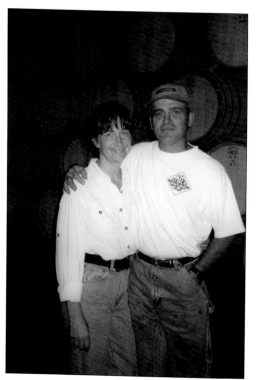

Ken Wright founded Panther Creek Cellars, a boutique winery, in the McMinnville area in 1986. Wright is known for his signature blends, as well as single-vineyard designate wines from Shea Vineyard, Temperance Hill, Freedom Hill, and Carter Vineyard. He has a reputation for making pinot noirs that are "big, fruity, collector-worthy pinot noirs." This image was a publicity photograph for the ¡Salud! auction held in 1999. Wright auctioned his wine to raise money for the program. Panther Creek Cellars celebrated its 30th vintages in 2016.

McMinnville's Power Station was a former power plant for the City of McMinnville that had been converted into a winery and tasting room. Ken Wright operated Panther Creek from there for several years. He sold the winery to Ron and Linda Caplan in 1994. They brought on Mark Vlossak of St. Innocent as a consulting winemaker. Wright founded Ken Wright Cellars in Carlton and served as consulting winemaker for other vineyard owners. The Power Station is now home to Elizabeth Chambers Cellars.

Panther Creek saw some shuffles in ownership and winemakers. The Chambers family from Eugene bought Panther Creek in 2005. Daughter Elizabeth "Liz" Chambers, who had been general manager of Silvan Ridge since 1993, was tasked by her mother, Carolyn, to "make it work." Carolyn Chambers died in 2011, and the family sold Panther Creek to Bacchus Capital Management in 2013. Tony Rynders of Domaine Serene took over as winemaker for Bacchus. Liz Chambers retained the power plant location and established Elizabeth Chambers Cellars there. Both the Eugene and McMinnville wineries operate under the Elizabeth Chambers Cellars brand. (Chris Bidleman.)

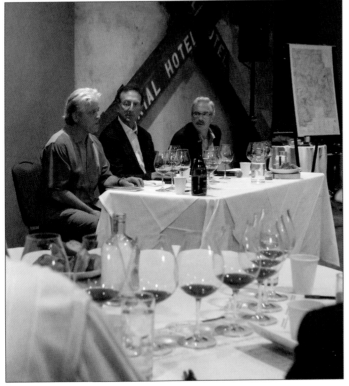

A 30th year celebration of Panther Creek Cellars was held in 2016, both in Portland and in New York City. Ken Wright shared his recollections of the early days of the winery and building relationships with vineyard owners. Tony Rynders was also there to share his perspective on what had transpired over 30 years. (Chris Bidleman.)

Tony Rynders has spent the past 20 vintages developing his winemaking skills in some of the best wineries in Oregon, Washington, California, Italy, and Australia and is recognized as one of America's most highly acclaimed winemakers. He was the head winemaker at Domaine Serene Winery/Rockblock Cellars for 10 years, during which time he obtained more 90-plus point scores from *Wine Spectator* than any other winemaker during this period. Renowned author Robert Parker Jr. described Panther Creek as "one of the most consistent, high quality Oregon wineries . . . producing some of Oregon's most concentrated and age-worthy wines." (Chris Bidleman.)

Dick and Betty O'Brien's interest in wine began on a trip to Germany in 1980, where they stayed with a family who had a small vineyard on the property and made their own wines. Impressed with the small operation, the O'Briens approached Betty's parents, Elton and Florine "Peggy" Ingram, about planting a vineyard of their own. Though skeptical about their lack of farming experience, they agreed, giving the couple a five-acre plot. The O'Briens educated themselves on growing grapes, and as luck would have it, Betty met Jim Bernau in her graduate school classes at Willamette University. Bernau planted his Willamette Valley Vineyard in 1983, the same year the O'Briens planted theirs. When the O'Briens retired in 2015, they granted Bernau a long-term lease of the vineyard; Betty's brother had previously sold his property to Bernau. When the O'Briens die, Bernau will purchase the land, with the proceeds benefiting both Oregon State University (to fund a viticulture extension agent position) and Chemeketa's Northwest Wine Studies Center.

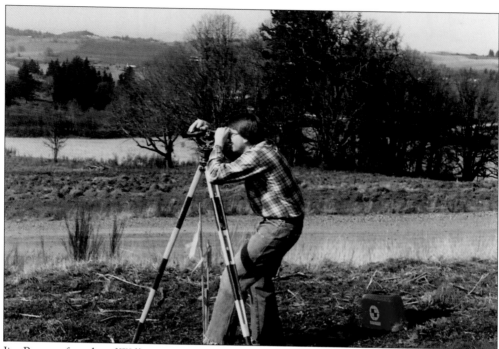

Jim Bernau, founder of Willamette Valley Vineyard in Turner, purchased property for his vineyard in 1983, clearing away a plum orchard and scotch broom before planting pinot noir and chardonnay. He utilized an innovative method to fund the business—selling shares of stock in the company, which resulted in more than 7,000 owners of common and preferred stock sold on NASDAQ. Bernau's innovation did not stop there. Though he had a tasting room at the vineyard at Turner, he opened a tasting room in Dundee as well. He has grown his vineyard through partnerships with Bill Fuller of Tualatin Valley Vineyards in 1997, Betty and Dick O'Brien in 1983, and Loeza Vineyard, which was planted in 2015. The winery now sources its pinot noir from 500 acres of estate-grown vineyards. (Both, Willamette Valley Vineyards.)

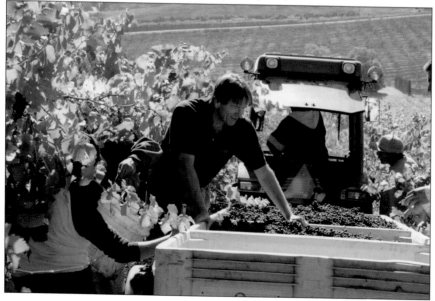

Hungarian-born Josef Fleischmann grew up with wine in his veins. His grandfather was a winemaker in central Hungary. He fled with his family to Germany, where he studied to become a baker, then immigrated to the United States where he met his wife, Lilli, in a German community in Chicago. The couple moved to Oregon, settling in the Canby area, with the intention of continuing the bakery, adding a farm and vineyard as well. The Fleischmanns planted the first vineyard in 1978, made their first commercial vintage in 1983, and founded St. Josef's Estate Vineyard and Winery in Canby in 1983. The St. Josef's 1985 cabernet won a gold medal at the New York Wine Summit, besting several California wineries, including Robert Mondavi. The Fleischmanns offer guests a variety of opportunities to experience their winery, including a grape stomping event every harvest; Red Lips and Tulips, which features Hungarian food and music; and a spring Founder's Day event. (Both, St. Josef's Estate Vineyard.)

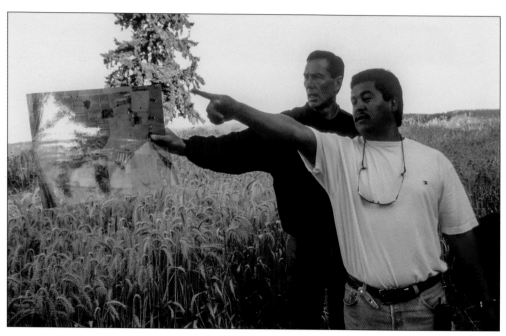

Above, Bill Stoller, left, owner of Stoller Vineyard, and former vineyard manager Jaime Cantu discuss the planting of a vineyard. Stoller was born on the property and raised on the nearby family farm outside of Dayton. During his professional career, Stoller cofounded Express Employment Professionals, currently the largest privately owned staffing agency in the world, with more than 600 offices in four countries. His business success allowed him to pursue his passion for wine and contribute to the community. Stoller's father and uncle had a turkey farm on the property since 1943, and when the operation closed in 1993, Stoller bought the property from a cousin. From his experience as co-owner of Chehalem Vineyards, he knew the property, with its rocky soil and south-facing slope, would be perfect for a vineyard. Stoller is dedicated to being a good steward of the land and has created practices that will ensure its sustainability and protect the environment for the next 200 years. Stoller Vineyard earned the first LEED Gold certification in the world. Below is an aerial photograph of the original turkey farm. (Both, Stoller Vineyards.)

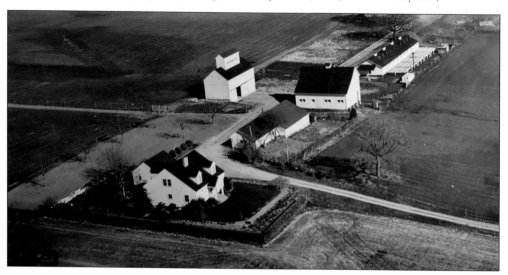

Lynn Penner-Ash is considered Oregon's first woman winemaker of note. She began her career in Oregon at Rex Hill Winery in 1988, then founded Penner-Ash Vineyards with her husband, Ron Penner-Ash, in 1998. Lynn is known as a master blender and makes wines from grapes grown in vineyards throughout the Willamette Valley's seven AVAs. The couple built their sustainable gravity-flow winery in 2005. The tasting room has a 360-degree view of the valley. Penner-Ash viognier was served in September 2015 at a White House state dinner, honoring Pres. Xi Jinping of China. (Penner-Ash Vineyards.)

Luisa Ponzi returned from Beaune, France, following her postgraduate enological studies. She received the certificate Brevet Professionnel D'Oenologie et Viticulture, the first American woman to earn such a prestigious distinction. She took over the reins of winemaking from her father, Dick Ponzi, in 1993, completing her first vintage. (Ponzi Vineyards.)

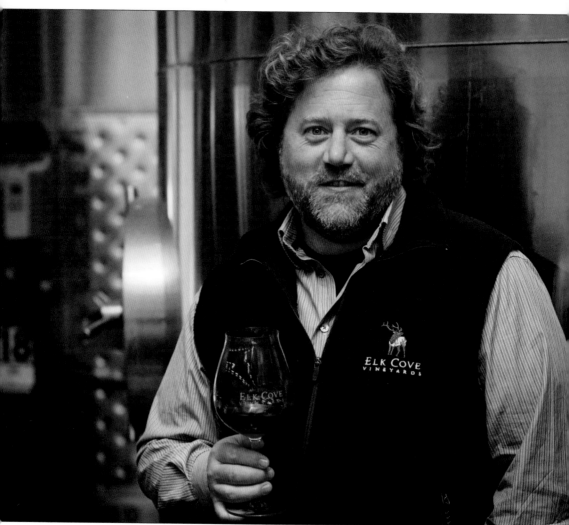

In 1995, shortly after Luisa Ponzi took over winemaking at Ponzi Vineyards, Adam Campbell joined forces with his parents, Joe and Pat Campbell, at Elk Cove Vineyards. All five of the Campbell children had worked in the vineyard, but with Adam, the work hit a powerful chord. He is now responsible for making Elk Cove's wines, overseeing six vineyard sites with 350 planted acres. That is over 10 times the total acreage of Oregon vineyards when Pat and Joe planted their first vines. Adam can claim to be a fourth-generation farmer and a second-generation winemaker. (Elk Cove Vineyards.)

Another family with deep roots in Willamette Valley agriculture is the Bayliss family. Daniel and Emma Bayliss purchased a half-ownership in the Bayliss homestead in 1906, beginning what would be a fourth-generation family farm. The property had to be clear cut of old-growth timber before it could be farmed and the timber hauled 25 miles by horse cart to Portland. The farm produced wheat and potatoes for generations until 1993, when Mike and Drenda Bayliss proposed to their children that they plant a vineyard on part of the property. The children were much more interested in making wine than in growing wheat or potatoes. The family dubbed the winery Ghost Hill Cellars, based on a tale that dates to the late 1800s of a miner murdered for his stake. To this day, the ghost of the miner roams the hill looking for his murderer, or so they say. (Both, Bayliss family collection.)

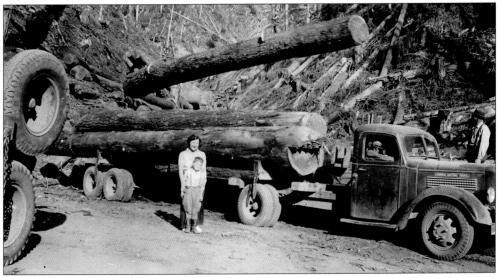

Motivated by the results of blind tastings of Willamette Valley pinot noirs against fine French burgundies in 1979 and 1985, Robert Drouhin, of the famed French winemaking family Maison Joseph Drouhin, came to Oregon to purchase property. David Adelsheim helped him find the right property, and Drouhin purchased 100 acres in the Dundee Hills. Drouhin's daughter Veronique, a trained enologist, was asked to oversee the operation, dubbed Domaine Drouhin Oregon. She came in 1986 and interned at The Eyrie, Adelsheim, and Bethel Heights, learning from David Lett, David Adelsheim, and Terry Casteel and helping with a harvest. She made her first vintage in 1988. Pictured above are, from left to right, David Adelsheim, Robert Drouhin, and Veronique Drouhin taking the first steps on the property. (Both, Domaine Drouhin Oregon.)

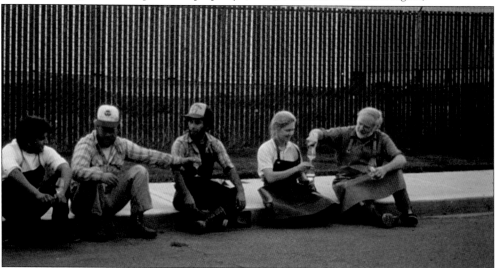

Veronique Drouhin is pictured with Nick Peirano, chef and owner of Nick's Italian Café in Dundee, the first area restaurant to feature Oregon wines on its menu. Nick's was a gathering place for those in the wine industry, as well as wine enthusiasts. Having local wines on the menu made them more accessible to diners, a key to getting consumers to taste different wines. (Domaine Drouhin Oregon.)

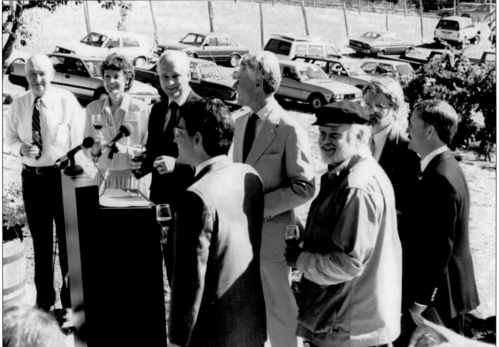

When Domaine Drouhin Oregon opened in 1988, Gov. Neil Goldsmith and other dignitaries attended the event. Pictured are, from left to right, unidentified, wine distributor Karen Hinsdale of Henny-Hinsdale Distributing, Governor Goldschmidt, Robert Drouhin, David Adelsheim (wearing glasses), David Lett (in cap), and two unidentified on either side of Lett. Drouhin's investment in Oregon was a coup. Prior to that, winemaking in Oregon was regarded as a cottage industry with potential, but with recognition from Burgundy, there was no denying that world-class pinot noir was being made in the Willamette Valley. Drouhin encouraged other winemakers to come to the Willamette Valley. The foundation had been set for the wave of newcomers the state has seen in recent years, including California's Jackson Family Wines and Drouhin's burgundian colleague Louis Jadot. (Domaine Drouhin Oregon.)

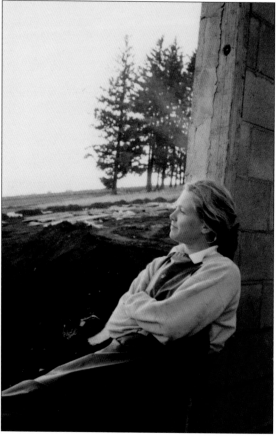

Veronique Drouhin and her father, Robert, share a peaceful moment in the winery. It is said that words like "finesse" and "elegance" describe Veronique and the wine she makes. Had Drouhin been an expert in making cabernet sauvignon, he might have settled in California. He visited the state in 1961, and California winemaker Robert Mondavi urged him to invest in California. But pinot noir was Drouhin's passion. He assembled a blind tasting of American pinot noirs and burgundies in 1979. An Oregon bottling by pioneer David Lett caught his attention, and Drouhin began exploring the New World region. In 1987, he found 100 acres in the Willamette Valley that he believed could make exceptional pinot noir. He asked his daughter Véronique, a trained enologist, if she would be willing to oversee the project, dubbed Domaine Drouhin Oregon. (Both, Domaine Drouhin Oregon.)

David Specter, founder and winemaker of Bells Up Winery, uses his musical background to give his wines a unique and memorable approach. "Bells up" refers to the dramatic moment in classical music when the director instructs French horn players to lift the bells of their instruments to project sound with maximum intensity. Specter, a French horn player who performed throughout high school and college, says the winery is his "bells up" moment. He owns the winery with his wife, Sara Pearson Specter. (Bells Up Winery.)

Winemaker Andrew Beckham has combined his passions for art and wine at Beckham Estate Vineyard in Sherwood. He is believed to be the only vintner in the world who makes his own fermentation vessels using this method. These terra-cotta amphorae vessels were used as part of an ancient winemaking tradition thought to originate in the Republic of Georgia. (Robert Reynolds.)

After many years living, studying, and working in the Willamette Valley wine industry, Ken Pahlow and his wife, Erica Landon, founded Walter Scott Wines in the Eola Hills AVA in 2008. Their goal is to produce "clean, correct wines with tension and grace." Landon said Eola is derived from Aeolus, a Greek deity in charge of the winds, and is a tribute to the powerful, cool ocean winds that blow from the Van Duzer corridor over the AVA each afternoon, providing the cool nights that keep acids firm and are essential for optimal ripening of the grapes. The soil in Eola Hills is predominately volcanic soil that is more shallow and rockier than that found in other Willamette Valley AVAs. The thin soils drain quickly after rain, which allows fruit to hang on the vines longer into the fall for maximum flavor development. This, Landon says, allows Eola Hills winemakers to make "wine they are proud to produce." (Walter Scott Wines.)

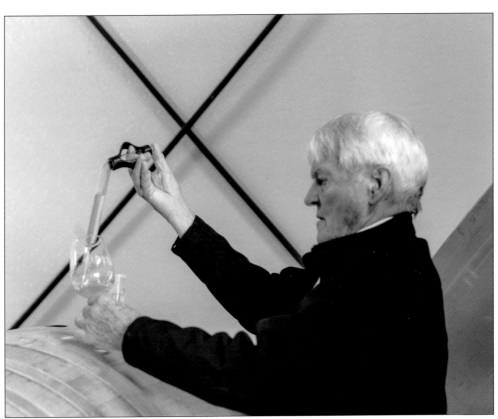

Don Hagge, founder of Vidon Vineyards in the Chehalem Mountains AVA, was raised on a farm in North Dakota, so farming a vineyard brings him special joy. He discovered fine wines while studying engineering at the University of California, Berkeley. While in France doing postgraduate work, he fell in love with the wines of Burgundy. He spent his career in the high-tech industry and even worked with the space program in Houston before coming to Oregon. As an engineer, Hagge sees challenges as opportunities to use science. He uses gravity to avoid pumping, and ferments his wine in flextanks, long-lasting vessels made of food-grade polyethylene. He says he does not have to top off the barrels to account for the "angel's share," the evaporation that naturally occurs with wood barrels. The property is powered by solar energy. Vidon released a series of wines with NASA–inspired names in 2016. (Both, Vidon Vineyards.)

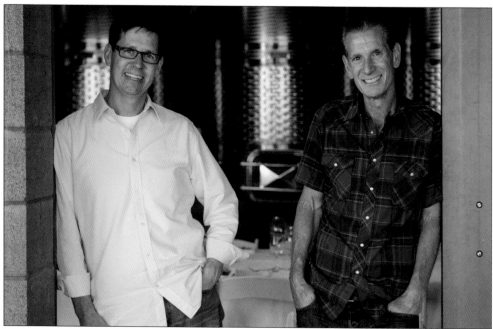

David Nemarnik, right, is the visionary behind Alloro Vineyards. He grew up helping at his family's business, Pacific Coast Fruit Company, which had a longstanding commitment to slow-food principles. After a successful career in the family business, he set out to create world-class pinot noir in a manner that honored his family traditions and respect for the land. He firmly believes fruit quality and vineyard health improve with sustainability, so keeping the farm's ecology in balance is essential. The farm is Salmon Safe and LIVE certified. At left, winemaker Tom Fitzgerald's goal is to make graceful, elegant wines that display the purity of the fruit, the textural focus—mouth feel, body, and balance of the wine, and expressive aromatics. His personal vineyard in the Dundee Hills is planted with the same vines as Alloro. Although he uses the same methods to make Elevee Wines, the wines taste different and are reflective of each site. Below, wine enthusiasts walk the vineyard with Nemarnik, second from right, and Fitzgerald, far right. (Both, Alloro Vineyards.)

Four

TELLING THE WORLD ABOUT PINOT NOIR

Pinot noir is created around the world but requires specific conditions for it to be made exceptionally. To bring awareness to the Willamette Valley—the region where it thrives—the International Pinot Noir Conference was founded by Willamette Valley winemakers and McMinnville Chamber of Commerce members in 1987. The weekend-long event is intended to provide winemakers, wine enthusiasts, journalists, and chefs an opportunity to learn more about the wine, sample it, and enjoy fine foods paired with it. The conference is held each July on the Linfield College campus in McMinnville. Attendees come from around the world, and international guests and speakers are invited to attend.

To train local vineyard workers, winemakers, and those interested in pursuing careers in the wine industry, Chemeketa Community College and Oregon State University (OSU) offer professional coursework. Chemeketa's program prepares students for careers in wine business, winemaking, and vineyard management. OSU offers a viticulture and enology program to prepare people for work as vineyard managers, winemakers, viticulturists, and wine industry consultants.

Linfield College offers a minor in wine studies, plus online certification programs for wine marketing and wine management and an immersion program that gives students a behind-the-scenes experience.

Winemakers and others involved in the wine industry recognize that vineyard workers are critical to the success of the industry; without their expertise, the vineyards would not be maintained properly and harvest, as well as other crucial parts of the winemaking operation, could not happen. Recognizing that migrant vineyard workers did not have access to health care, in 1991, a group of winemakers formed a partnership with Tuality Healthcare physicians to develop a program that would provide free medical and dental care for vineyard workers and their families. Health education is a major focus of the program, as is helping patients navigate the health care system. The program is unique to Oregon, allowing workers access to health care in the field and at clinics. No other state in the country has such an effective and far-reaching program to support the seasonal worker population. The program is called ¡Salud!, a toast meaning "to your health," and is entirely funded by the winemakers. Each fall, the ¡Salud! Auction, a highlight of the social calendar, is held. Winemakers offer their best pinot noir at the auction, raising hundreds of thousands of dollars to support the program. Some wineries also donate a portion of or their entire tasting fee.

Today, most vineyard workers are year-round residents and highly specialized in vineyard management skills. The health care program has had a positive impact on their quality of life, and workers are appreciative of it. The winemakers believe it is their responsibility to provide this health care.

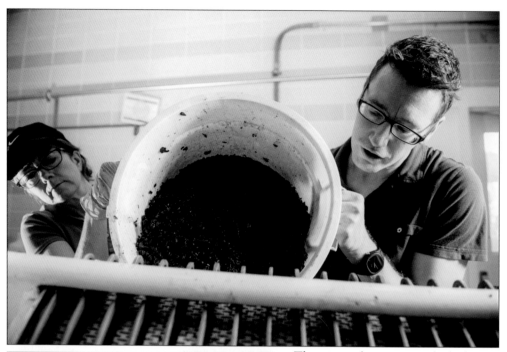

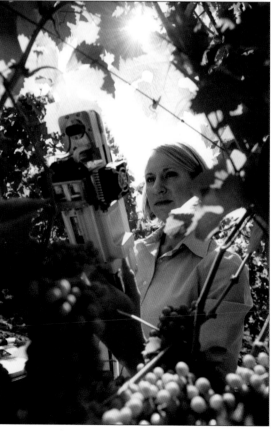

The winemaking pioneers looked to Oregon State University early on to help improve the wine industry. Working through the food sciences lab and agriculture department, they built a viticulture and enology program to prepare students for work in vineyards and wineries. Chemeketa Community College began a program to train people for jobs in the wine industry as well. (Both, Oregon State University.)

The International Pinot Noir Conference was founded by the McMinnville Chamber of Commerce, including winemakers and wine industry members, to bring commerce to McMinnville. The festival brings people from all over the world each summer for a long weekend of lectures, tastings, fine dining, and opportunities to meet winemakers. The event takes place on the Linfield College campus. A popular dining event is the dinner where salmon is cooked by a Native American method over open coals.

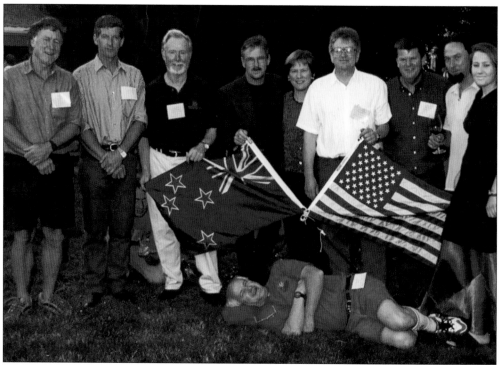

People can choose to attend all the events of the International Pinot Noir Conference or just the Sunday afternoon tasting and dinner. Pinot noir producers from around the world are invited to attend the event, like this group from New Zealand who attended in 1993. Guest speakers are often top experts from around the world who share knowledge about creating the best pinot noir they can.

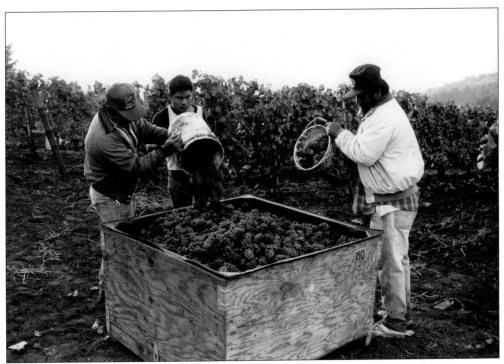

Vineyard workers often start at first light at one vineyard, finish picking, and then move onto another vineyard. Though many vineyard workers are year-round residents and have been highly trained in their work, many are still migrants and lack the security of health care. The ¡Salud! program provides that safety net for the workers and their families. (Dobbes Family Estate.)

Two bidders raise their paddles during the ¡Salud! Auction held at the Governor Hotel in Portland in 2004. Most winemakers regard it as their responsibility to donate directly to the program and to the ¡Salud! Auction each fall. Many encourage consumers to donate as well, or donate their tasting room fees to the program. The program is another example of the collaborative spirit of the Willamette Valley winemakers.

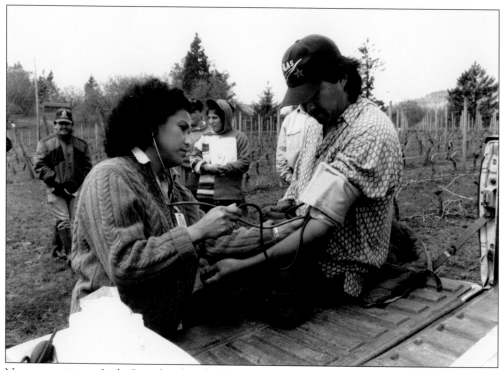

Nurse practitioner Leda Garside takes the blood pressure of a vineyard worker. The mobile clinic makes it simpler for workers to get needed health care. There are also stationary clinics in the communities that families and workers are welcome to utilize. The free health care has improved the quality of life for the workers and their families. The workers like sharing the progress they are making toward health goals, such as lowering cholesterol, losing weight, or working more ergonomically. They motivate each other and take pride in their success. Winemakers are proud of the program, too, and encourage consumers to donate to the program as well. In fact, there is a sense that if one drinks Oregon wine, they should support the ¡Salud! program.

The medical staff of ¡Salud! takes special care to educate workers on ergonomically correct methods of doing their work, since much of it is repetitive and done quickly, like cutting grapes off vines, stooping low, and carrying heavy buckets. The medical care is available to all family members.

Five

Experiencing the Terroir

In 50 short years, the Willamette Valley wine industry went from being a hopeful endeavor to a thriving enterprise. It is recognized as one of the finest pinot noir–producing areas in the world, and other cool-climate varieties, including pinot gris, pinot blanc, chardonnay, Riesling, and Gewurztraminer, are all equally at home in the valley.

The Willamette Valley is Oregon's agriculture center. The valley floor's rich alluvial soil is perfect for supporting grass and food crops but not for high-quality grape growing. However, the hillsides, with varying mesoclimates and a selection of volcanic, loess, and sedimentary soils, proved to be the perfect environment for growing grapes. A mesoclimate is the climate of a grape-growing site, the intermediate scale between a macroclimate (a large region) and a microclimate (the vicinity immediately around the grapes—the leaf canopy, vines, and grape clusters).

Terroir—the environmental conditions of a place, particularly the soil and climate, is of importance in the Willamette Valley. That sense of place is part of what cements the collaborative spirit of Willamette Valley winemakers. They recognize that even if they plant the same varietal clones and use the same vineyard management practices and winemaking methods as a neighboring winemaker, the wines produced will be different. That sense of place translates intimately into award-winning wines.

The Willamette Valley AVA encompasses 3,438,000 acres; different regions of the valley have different soils, producing characteristics in the fruit unique to that area. In yet another collaborative measure, winemakers in the Willamette Valley AVA worked to set up six sub-appellations, based on unique terroir or characteristics of the region. The proposed sub-appellations were approved by 2006.

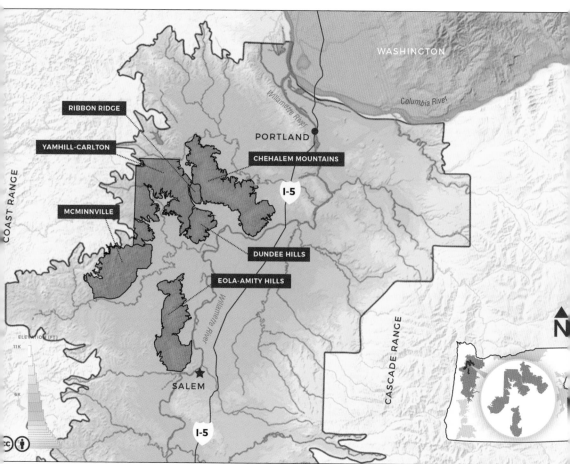

The Willamette Valley is a large region, with differing soils and climates and unique mesoclimates. The mesoclimate is the climate of the grape-growing site—a sort of middle ground between the macroclimate of the larger area and the microclimate of the area immediately around the grapes, such as the leafy canopy, grape clusters, and vines. This mesoclimate, soil, and climate, as well as the vineyard management skills and winemaker's craft, all combine to give the wine its terroir. Recognizing different regions of the valley had different characteristics of soil, climate, and terroir, winemakers have developed six sub-appelations within the Willamette Valley AVA. This map shows the relationship of the sub-appelations. (Oregon Wine Board.)

The Dundee Hills AVA was established in 2005. This is the most densely planted region in the Willamette Valley and the state of Oregon. The AVA overlooks the Willamette River to the south and the Chehalem Valley to the north and is protected from ocean climate by the Coast Range. The soil is basalt. (Oregon Wine Board.)

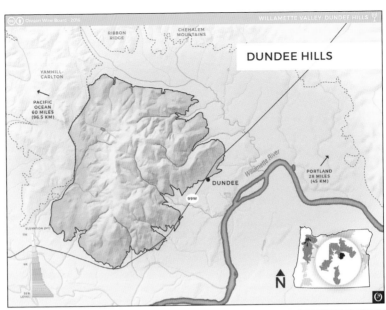

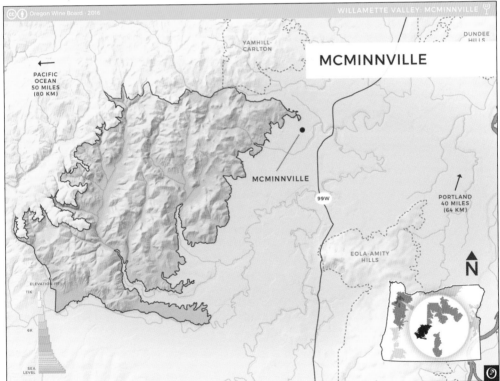

Established in 2005, the McMinnville AVA is located just west of McMinnville, stretching 20 miles south and southwest to the mouth of the Van Duzer corridor. The soils are primarily uplifted marine sedimentary, loams, and silts, with alluvial overlays and a base of uplifted basalt, uniquely shallow soils for grape growing. The planted slopes sit in the protective weather shadow of the Coast Range, and rainfall is lower than on sites to the east. The primarily east- and south-facing sites take advantage of the drying winds of the Van Duzer corridor. (Oregon Wine Board.)

The Ribbon Ridge AVA, established in 2005, is a uniformly shaped 3,350-acre plot of land with soil made of ocean sediment uplifted off the northwest end of the Chehalem Mountains. The AVA's characteristics include uniform and unique ocean sedimentary soil and a geography that is protected climatically by the large land masses around it. (Oregon Wine Board.)

Yamhill Carlton AVA was established in 2005. It lies north of McMinnville to the foothills of the Coast Range, covering nearly 60,000 acres, centered around the hamlets of Yamhill and Carlton. Low ridges surround the communities in a horseshoe shape. The AVA has a unique set of growing conditions. The Coast Range soars to nearly 350 feet, casting a rain shadow over the entire district, and more protection is afforded by the Chehalem Mountains to the north and Dundee Hills to the east. The coarse-grained marine sedimentary soils native to the area are some of the oldest soils in the valley. They drain quickly, creating a natural deficit-irrigation system. (Oregon Wine Board.)

Chehalem Mountain AVA was established in 2006. This is a slim, 20-mile by 5-mile, single uplift landmass in the north Willamette Valley and includes several peaks of note—Ribbon Ridge, Parrot Mountain, and Bald Peak, which at 1,633 feet is the highest elevation in the AVA. The elevation affects the weather; the geography and climate differ, too. Three soils types are represented in the AVA, including basaltic, ocean sedimentary, and loess. (Oregon Wine Board.)

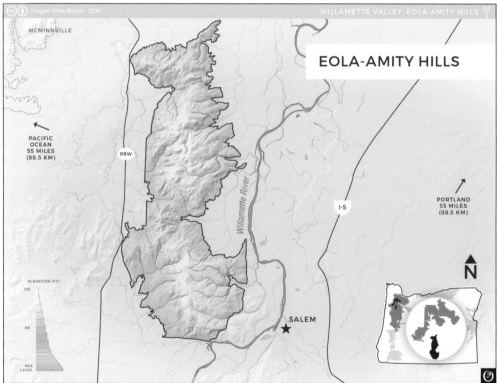

Eola Amity Hills AVA was established in 2006. It is located adjacent to the Willamette River and straddles the 45th parallel on the south side, which also runs through Burgundy, France, and the Amity Hills to the north. The soils are shallow, predominantly volcanic basalt from ancient lava flows, combined with marine sedimentary rocks and/or alluvial deposits. This makes for shallower, rockier soil that drains well and produces smaller grapes with concentrated flavor. The Van Duzer corridor provides a break from the Coast Range that allows cool ocean winds to flow and drops the temperature dramatically, especially on summer afternoons, which helps keep acids firm. (Oregon Wine Board.)

Stoller Family Estate was established in 1943 as a turkey farm. Owner Bill Stoller was born on the farm and raised nearby, then purchased the farm for a vineyard when his father and uncle ceased operations. He knew the southern-sloping and rocky terrain with low-yield soil would be ideal for growing grapes for world-class wines. (Stoller Family Estate.)

Amity Vineyards is a great blend of the Willamette Valley's pioneering spirit. Founded in 1974 by Myron Redford, the vineyard strives to be patient and humble while also exploring and trying new things. The vineyard was purchased in 2014 by Ryan Harms of Union Wine Company and his brother Eric Harms. (Myron Redford collection.)

David Nemarnik owns and operates Alloro Vineyard and Estate as a holistic Old World farm. He grows hay for the Hereford cattle and heritage sheep he raises, fertilizes crops with manure, and uses sheep to mow the vineyard cover crops. But he also has both feet firmly planted in the 21st century. Solar panels on the property provide 100 percent of the power needed to run the operation, and the surplus goes back to fuel the rest of the grid. (Alloro Vineyard.)

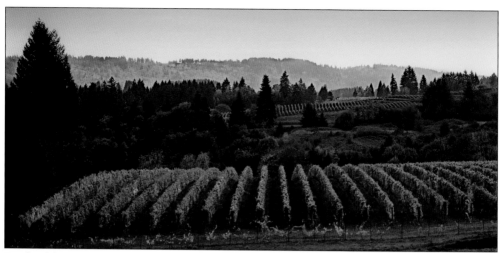

Portland fine art photographer Ron Kaplan took this photograph of a Willamette Valley vineyard in autumn 2015. Kaplan has been teaching fine art photography in Portland since 2007 and is also a winemaker.

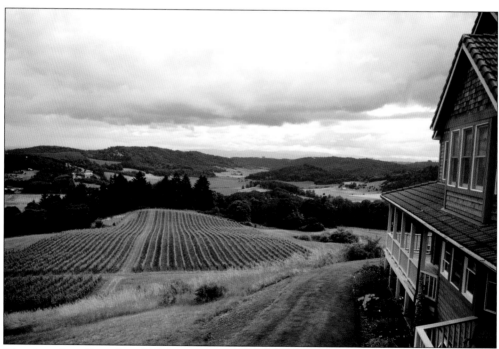

The views from Youngberg Hill Vineyard and Inn are spectacular. Inspired by a childhood spent on a farm in Iowa and wishing to share that with his children, Wayne Bailey and his family began farming the vineyard organically in 2003 and are moving to biodynamic farming practices. Bailey makes pinot noir and pinot gris from estate-grown fruit. Located just outside of McMinnville, the inn is a popular place for wine tourists to stay during their visit to the Willamette Valley wineries. (Youngberg Hill Vineyard.)

Six

LOOKING TO THE FUTURE

Since there was no history to build upon, the Willamette Valley pioneers had to construct a wine industry from the ground up. Their success was heralded loud and clear when *Wine Enthusiast* named Oregon's Willamette Valley as Wine Region of the Year in 2016. The AVA is home to more than 530 wineries and approximately 20,000 acres of vineyards. The Willamette Valley bested the regions of Champagne, France; Crete, Greece; Sonoma, California, and Provence, France, for the title.

"We are humbled by this award, especially as we also acknowledge the great regions who were also nominated for Wine Region of the Year," said Sue Horstmann, executive director of the Willamette Valley Wineries Association. "This award validates all of the hard work of each and every winemaker in the Willamette Valley over the course of our 50-year history. Our region is now the epicenter of Oregon's $3.35 billion per year wine industry with more than 500 wineries. And in many ways, it's just getting started." David Beck, chairman of the Oregon Wine Board, stated, "This award is the direct reflection of the attention and care given by Oregon's grape growers and winemakers from vine to bottle. Oregon's wine industry is largely comprised of small to mid-sized family farms, more than half of which produce fewer than 5,000 cases of wine per year. Winegrowers pour countless hours into honing their craft and tending to their wines to ensure every grape is of the highest quality."

Wine Enthusiast's list in 2016 included other nominations from the Willamette Valley. Jim Bernau, founder of Willamette Valley Vineyards, was nominated for Person of the Year, and King Estates was nominated for American Vineyard of the Year.

After Jim Bernau founded Willamette Valley Vineyards in 1983, he built the formerly little-known region into a contending wine-tourism destination. His vision was to take the winery's ownership public. Today, it is run by 7,000 owners and investors. Bernau's reach continues—in 2016, he broke ground on Pambrun vineyard and winery in Walla Walla, Washington. (Carolyn Wells-Kramer, CWK Photography.)

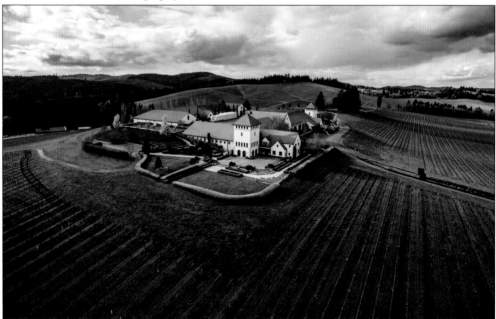

Located in the Eugene area, King Estate is the largest pinot gris producer in the country, and also makes a wide range of excellent pinot noir and the value brand Acrobat. King Estate was instrumental in 2016 in expanding the Willamette Valley AVA and recently announced its intention to be certified biodynamic. Founded in 1991, the property's 1,033 acres are organically farmed, including fruit and vegetable gardens, as well as the vineyards. (King Estate.)

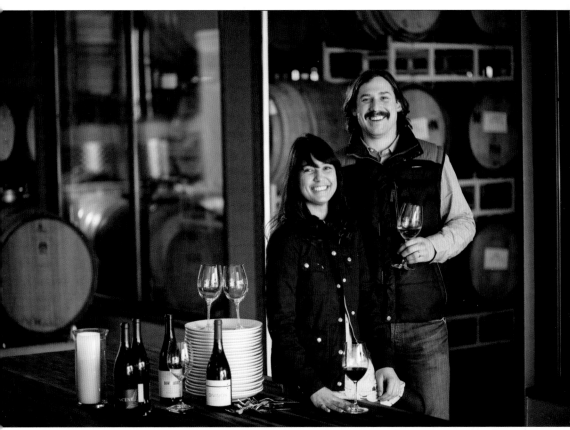

The Willamette Valley's urban wineries were represented in *Wine Enthusiast's* 2016 awards, too. The magazine's editors named Kate Norris and Tom Monroe, winemakers at Division Winemaking Company and founders of Southeast Wine Collective located in Portland, to their 40 Under 40 list, a list of 40 trendsetters under the age of 40 considered to be the most influential in determining what the public drinks. Within a 5,000-square-foot urban winery space, Norris and Monroe created a hub for custom-crush production and wine exploration. Visitors can taste creations from resident winemakers, as well as New and Old World picks at the winery's bar. "We are always tinkering with new wines, many with varietals not well known to the Willamette Valley," said Monroe. "We have a skin-fermented orange Chardonnay wine that we have been aging for three years coming out soon." The collective also hosts special events like Drink Chenin Day and the Nouveau Division Crawl, which celebrates Beaujolais Nouveau. Wine enthusiasts agree that the Willamette Valley wine industry is just hitting its stride. The handful of pioneers who started the industry here has grown into a league of more than 500 winemakers, producing world-class pinot noir and other cool-climate varieties including pinot gris, pinot blanc, chardonnay, Riesling, and Gewurztraminer. Through the characteristic collaborative spirit, and with an eye on sustainable practices, there is no doubt that the region will continue to flourish for generations to come. (Division Winemaking Company.)

DISCOVER THOUSANDS OF LOCAL HISTORY BOOKS FEATURING MILLIONS OF VINTAGE IMAGES

Arcadia Publishing, the leading local history publisher in the United States, is committed to making history accessible and meaningful through publishing books that celebrate and preserve the heritage of America's people and places.

Find more books like this at
www.arcadiapublishing.com

Search for your hometown history, your old stomping grounds, and even your favorite sports team.

Consistent with our mission to preserve history on a local level, this book was printed in South Carolina on American-made paper and manufactured entirely in the United States. Products carrying the accredited Forest Stewardship Council (FSC) label are printed on 100 percent FSC-certified paper.